# AIRBORNE CAMERA

## THE WORLD FROM THE AIR AND OUTER SPACE

Ethiopia, Somali, French Somaliland, Saudi
Arabia, South Arabia, Red Sea, Gulf of
Aden. Photographed from the spacecraft.
*Gemini XI*, 1966.

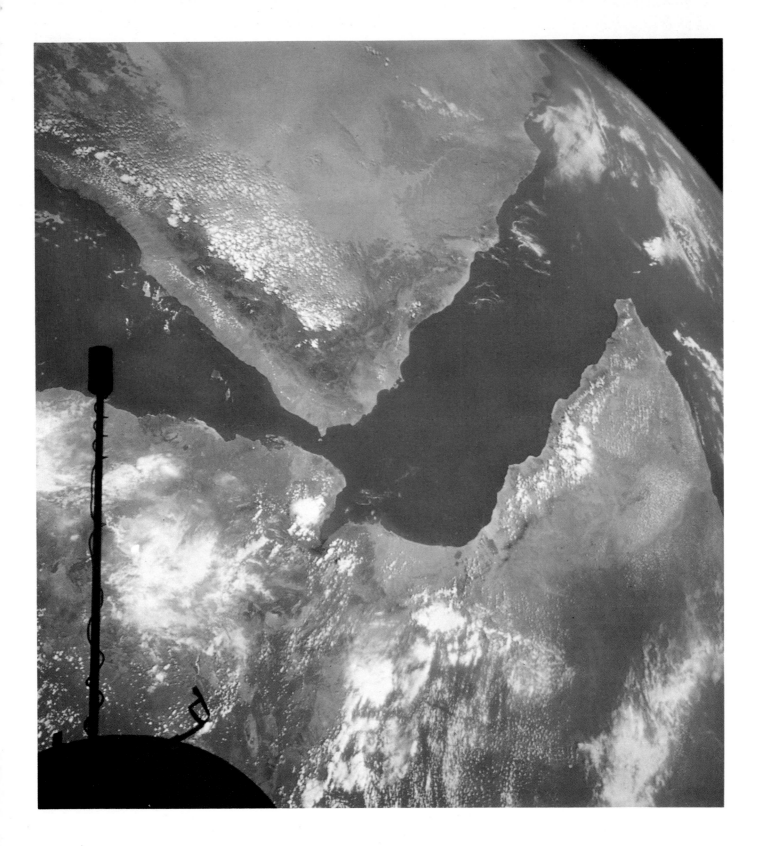

# AIRBORNE CAMERA

## THE WORLD FROM THE AIR AND OUTER SPACE

### BEAUMONT NEWHALL

HASTINGS HOUSE, PUBLISHERS     New York

*in collaboration with the George Eastman House, Rochester, N.Y.*

Published simultaneously in Canada by
Saunders, of Toronto, Ltd. Don Mills, Ontario

SBN: 8038-0335-4

Library of Congress Catalog Card Number: 69-15057
*Printed in the United States of America*

*"The airplane has unveiled for us the true
face of the earth. . . . We set our course for
distant destinations. And then, only, from
the height of our rectilinear trajectories,
do we discover the essential foundation, the
fundament of rock and sand and salt in which
here and there and from time to time life
like a little moss in the crevices of ruins
has risked precarious existence."*

ANTOINE DE SAINT-EXUPÉRY

# CONTENTS

## 10 THE EYES OF THE ARMY

Cameras found in wreckage of Zeppelin at outbreak of World War I, 1914, lead French to reactivate photographic section of air service. Royal Flying Corps considers amateur photography by flyers "disgraceful" until value proved. Pressure to produce air cameras: prototype built in a week. Improved cameras take photographs in succession and overlapping, to provide stereo vision. Principles of hyperstereoscopy. The Photographic Section, American Expeditionary Forces, commanded by Edward Steichen. His reminiscences. Need for automatic cameras. The German Rb camera of Oskar Messter. Production of photographs in the millions.

## 11 PHOTO RECONNAISSANCE IN WORLD WAR II

British Air Intelligence obtains prewar secret photo coverage of Germany from Frederick Sidney Cotton, a civilian. Cotton recommends use of swift, single seat plane to Royal Air Force for combat use. Spitfire adopted. U. S. Army Air Force F5 photo plane, adapted from P38. Courage of photo-pilots: Antoine de Saint-Exupéry, Col. Karl Polifka. Photos machine processed. The three phases of photo interpretation. Types of information revealed. Technique. Counter-photo reconnaissance measures. Attempt to continue photo reconnaissance to control the peace unsuccessful. High altitude overflights.

## 12 MAPPING THE WORLD AND EXPLORING THE PAST

Col. T. E. Lawrence proposes using idle Royal Air Force planes to map the Middle East by photography. Opposition by survey company. Measuring heights by stereoscopic vision: the "floating mark". Stereocomparators. Production of contour maps. Need for eliminating distortion in air photos. Air vision reveals features invisible on earth. Vegetation growing in soil, once disturbed, is of different color. O. G. S. Crawford and Alexander Keiller show potentials of air photography to archaeologists in their *Wessex from the Air* (1928). Value of air photography to geographers, civil engineers, city planners, foresters and others.

## 13 FROM OUTER SPACE

First spaceborne camera carried 65 miles in a V-2 rocket, 1946. Pictures relayed by the satellite *Explorer VI* (1959) of the earth from 19,500 miles show potentials of hyperaltitude photography for weather reconnaissance. The weather satellites *Tiros, Nimbus, Essa*. Hurricane warnings. *Mariner IV* radios pictures of Mars. *Lunar Orbiter I*: first satellite to photograph the globe of the earth. The *ATS* satellites: hourly coverage. Recovery of exposed film from satellites. MA-4: a quarter of the continent of Africa mapped in two minutes. Hyperaltitude photography reveals unknown terrain features. Photographs taken by astronauts. One analysis photograph of Australia indicates space photography the best way to study underdeveloped areas of the world. The Earth and the Moon photographed by the crew of *Apollo 8* in color, 1968. New materials and techniques extend photography beyond the visible.

# FOREWORD

With flight through the air and now in outer space a reality, our vision of the world and the universe has expanded far beyond our prevision or even imagination. Photography can hold still the fleeting glimpses of the world as seen by flyers: indeed it makes visible, through remote space-borne cameras, what man himself has not yet seen.

The camera, first airborne in 1858, has looked down upon the earth from balloons, kites, rockets and airplanes. These airviews were at first strange novelties; since they did not conform to the anthropocentric vision of established perspective they were hard to understand, even bewildering. But the new vision soon became accepted, as air travel became common, as painters experimented with abstractions to emphasize form, and as the usefulness of aerial photography became apparent.

In 1959 our vision was yet more greatly extended when we saw, for the first time, our world from 19,500 miles through the lens of America's spacecraft *Explorer VI*. It was a crude picture, intelligible only to experts, but so useful to meteorologists that spacecraft carrying cameras were sent yet further into space — to such distances that the pictures they relayed to Earth show our terraqueous globe as a planet. Suddenly, through sophisticated combinations of photographic technology and electronic systems for the transmission of images, we have visible proof of our position in the universe.

This book traces the growth of the expanded vision of our world which we owe to flight and photography. It is not a technological treatise, but a presentation and explanation of new visual dimensions.

I thank:

ROBERT M. DOTY, for making available to me the extensive research he did for his article "Aloft with Balloon and Camera" in *Image*, November, 1958.

CONSTANCE BABINGTON-SMITH, fellow photo interpreter in World War II, whose descriptions of photo reconnaissance in that conflict I have freely quoted from her book *Air Spy*.

THE NATIONAL AERONAUTICS AND SPACE ADMINISTRATION, especially Alfred Rosenthal, Historian of the Goddard Space Flight Center, and Richard Underwood, Technical Monitor for *Gemini* and *Apollo* Scientific Photography at the Manned Spacecraft Center.

WALTER W. FRESE, President of Hastings House, Publishers, Inc., for asking me to undertake this book; to Russell F. Neale, Editor, for his understanding of writing problems and recognition of my approach; to Al Lichtenberg, Art Director, for his acceptance of my original design of this book and his sharpening of it.

THE PHOTOGRAPHERS who have graciously allowed me to reproduce their photographs: individual acknowledgment is given in each caption.

NANCY NEWHALL, my wife and colleague, for encouraging me to undertake this book, for her ever helpful criticism of my efforts, and for her enthusiastic support.

THE STAFF OF GEORGE EASTMAN HOUSE, who not only aided me in writing this book, but assisted me greatly in preparing the exhibition upon which it is based; especially Pam Reed for typing and retyping my many drafts.

And many others who facilitated my research: Edgar Breitenbach and Alan Fern of The Library of Congress, Peter C. Bunnell of The Museum of Modern Art, New York, Barbara Chancellor, Charles Gibbs-Smith of the Victoria and Albert Museum, Jean Prinet of the Bibliothèque Nationale, Louis Walton Sipley of The American Museum of Photography, Archie Whitehead, historian of aviation, Walter Muir Whitehill, Director and Librarian of the Boston Athenaeum.

Beaumont Newhall
*The George Eastman House,
Rochester, N.Y.*

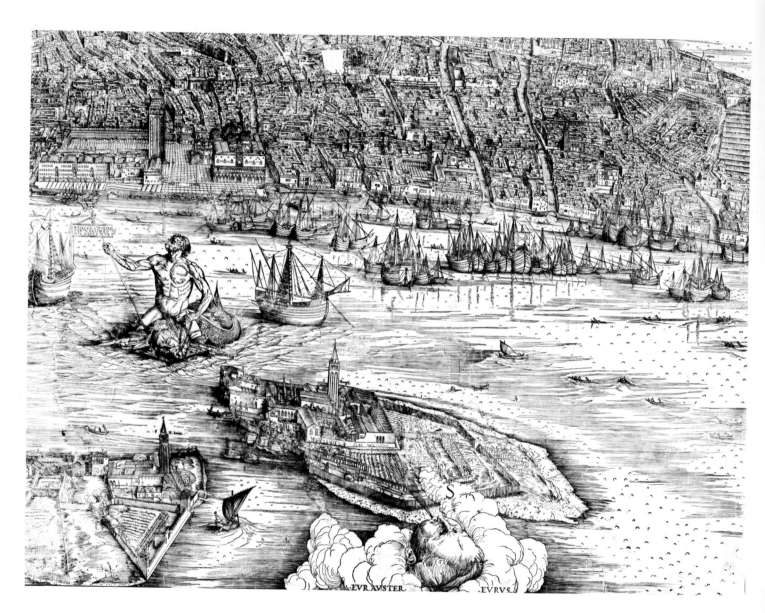

Bird's-eye view of Venice (detail).
Woodcut by Jacopo de Barberi, 1500.
The Museum of Fine Arts, Boston.

# 1 THE BIRD'S-EYE VIEW

The face of the earth from the air fascinated man before he was able to fly. He made his maps pictorial, imagining what he might see had he but wings. "Bird's-eye views" came into being at the moment when perspective was the concern of Western man, and Columbus sailed towards the ever-distant vanishing point.

Despite every attempt to project the mind's eye into space, these views were earthbound. They show the land seen from great heights, not from points suspended in space. We can read them with little trouble, for what we see in them is shown in its most familiar aspect. This was deliberate. The eighteenth-century English critic, William Gilpin, advised the painter to place whatever ships he might introduce into bird's-eye views "so far into the distance as to raise their masts above the horizon." Otherwise, he said, the result would be "rather unpleasing." He had no objection, however, to placing small boats and birds more directly beneath the eye, for they could be recognized without trouble: "The boat either fishing or in motion, the wheeling gull, or the lengthened file of sea-fowl, appear often to great advantage *against the bosom of the sea*; and being marked with a few strong touches, contribute to throw the ocean into perspective."

When man at long last was able to ascend into the air he marveled at the sight of the land stretched seemingly endlessly below him. Prince Pückler-Muskau, on an 1817 balloon ascension over Berlin, wrote:

"No imagination can paint anything more beautiful than the magnificent scene now disclosed to our enraptured senses: the multitude of human beings, the houses, the squares and streets, the highset towers gradually diminishing, while the deafening tumult became a gentle murmur, and finally melted into a deathlike silence.

"The earth which we had recently left lay extended in miniature relief beneath us, the majestic linden trees appeared like green furrows, the river Spree a silver thread, and the gigantic poplars of the Potsdam Allee, which is several leagues in length, threw their shadow over the immense plain. We had probably ascended by this time some thousand feet, and lay softly floating in the air. . . . I never before witnessed anything comparable to this scene even from the summit of the highest mountains; besides, from them the continuing chain is generally a great obstruction to the view, which, after all, is only partial; but here there was nothing to prevent the eye from ranging over the boundless expanse."

The forward motion of a balloon is effected by the wind alone; navigation is a prayer that the wind is blowing in the desired direction. Travel by balloon is silent and so seemingly motionless that aeronauts often threw out bits of paper to determine if they were ascending or descending. Time and again balloonists describe the earth as moving by a stationary spot in space. John Steiner wrote in 1857: "The earth itself appears literally to consist of a long series of scenes, which are being constantly drawn along . . . and conveying the notion that the world is an endless landscape stretched upon rollers, which some invisible spirits are revolving, for his especial enjoyment, while the aerial adventurer himself is unconscious of any motion."

The appearance of the world from the air was often entirely different from what had been expected.

John Wise, America's leading aeronaut, flew over Niagara Falls in 1847, in his balloon. In his air log he noted: "My eye soon rested upon it, and after scanning it for a few moments I involuntarily cried out, 'Is that the falls?' And no wonder I was surprised, for it looked like a cascade such as we see in pleasure gardens. I was disappointed, for my mind had been bent upon a soliloquy on Niagara's raging grandeur, but it was a bubble, it looked too small. . . . The little frothy bubble had too much the appearance of a foaming glass of London brown-stout."

Perhaps Wise expected a sight such as George Catlin

imagined when he painted his "Topography of Niagara" in 1827. The picture is an astonishing prediction of what airmen call a vertical view (as opposed to the oblique view), when the camera axis is vertical and the picture plane horizontal. It is tempting to assume that Catlin saw the Falls from a balloon, but had he done so he surely would have noted the fact; instead he captioned his lithograph of the painting: *"Birds-eye view taken from Mr. Catlin's* Model, *which was made from a careful survey."* Note the emphasis upon the word "model": Catlin obviously felt the need to document such a startling picture. He drew the ground from a viewpoint directly over the center of the picture. The shoreline is as precise as a map; the roads are of uniform width; the houses and trees of equal size. Yet he was not able to resist exaggerating the perspective of the Falls themselves; they are drawn from another viewpoint, far distant from the center, so that the mighty torrent of cascading water can be seen.

True balloon views of the earth were seldom accepted as landscapes. Philip Gilbert Hamerton, the most popular English art critic of the 1880s, opened his book *Landscape* by imagining what the Archangel Raphael might have seen on his flight from Heaven to the Earthly Paradise, bearing God's message to Adam:

"By the help of our modern knowledge we may imagine the approach to the earth as it would appear to one of us if he were permitted to fly like Raphael through interstellar space. It would first become visible as a mere point of light, then as a remote planet appears to us; after that it would shine and dazzle like Venus; then we should begin to see its geography as we do that of the moon; and at last, when we come within three terrestrial diameters, or about twenty thousand miles, we should distinguish white icy poles, the vast blue oceans, the continents and larger islands glistening like gold in the sunshine, and the silver-bright wandering fields of clouds. Nearer still, we should see the fresh green of Britain and Ireland, the dark greens of Norwegian and Siberian forests, the grayer and browner hues of countries parched by the sun, the shining courses of the great rivers. All this would be intensely, inconceivably interesting; it would be an unparalleled experience in the study of physical geography, but it would not yet be *landscape*. On a still nearer approach we should see the earth as from a balloon, and the land would seem to hollow itself beneath us like a great round dish, but the hills would be scarcely perceptible. We should still say, 'It is not landscape yet.' At length, after touching the solid earth, and looking round us, and seeing trees near us, fields spread out before, and blue hills far away, we should say, 'This, at last, is *landscape*. It is not the world as the angels may see it from the midst of space, but as men see it who dwell in it, and cultivate it, and love it.' "

In contrast, Thomas Monck Mason found the unfamiliar vision from above most stimulating and beautiful. In his book *Aeronautica* he describes the flight he made in 1836 in *The Royal Vauxhall Balloon* with the aeronaut Charles Green, and Robert Holland, a Member of Parliament. The flight was a long distance record: they covered 500 miles, from London to Weilberg, Germany (some 30 miles outside Frankfurt am Main) in 18 hours.

"The aeronaut quits the earth to assume a station in the zenith of his own horizon. . . . There projected upon a plane at right angles to his line of vision, the whole adjacent surface of the earth lies stretched beneath him, affording an heterogeneous display of matters at once interesting and incongruous. Distances which he used to regard as important, contracted to a span; objects once imposing to him from their dimensions, dwindled into insignificance; localities which he never beheld or expected to behold at one and the same view, standing side by side in friendly juxtaposition; all the most striking productions of art, the most interesting vari-

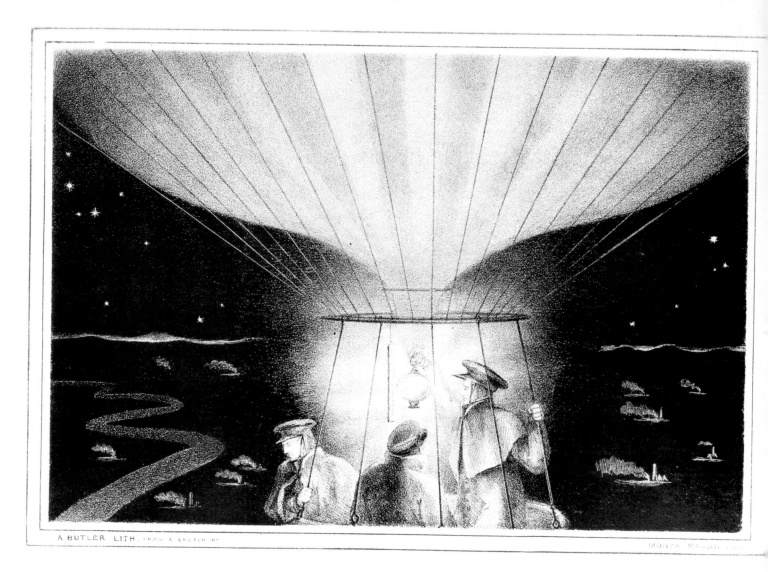

The Royal Vauxhall Balloon over Liège,
Belgium. Lithograph by A. Butler from
sketch by Thomas Monck Mason.

eties of nature, town and country, sea and land, mountains and plains, mixed up together in the one scene, appear before him as if suddenly called into existence by the magic virtues of some great enchanter's wand.

"It is not, however, to the objects alone, magnificent and interesting as they may be justly deemed, so much as to the modifications they undergo from the unusual manner in which they are viewed, that is mainly attributable that peculiar effect by which the terrestrial landscape is so notably distinguished in the estimation of the aerial admirer. Seen, in the first place, from above, everything that meets his eye, meets it under a novel aspect, and one which no other situation can in like manner and to the same extent enable him to enjoy. . . . All the ordinary qualifications of such scenes become, in fact, annihilated, and the eye for the first time beholds a picture of nature on the vastest scale, both as to size and magnificence, in the construction of which none of the complicated laws of linear perspective are at all involved. . . .

"Were I to institute a comparison with any of the more familiar methods of delineating nature, for the purpose of giving to those who never witnessed it, an idea of the appearance which the scene below us, especially the city and its immediate vicinity, bore at this period of our voyage, I should be inclined to say that it more nearly resembled in its effect the mimic representations of some vast camera-obscura, in which, with all the fidelity of nature itself, the most rigorous observance of proportion between the size and motion of the various bodies, is combined with the most perfect delineation of their minutest forms throughout every scale of decreasing magnitude, until they no longer continue to be discernible."

Monck Mason wrote these words in 1836. The camera obscura was then widely used as a visual aid by draftsmen. Already its image had been experimentally fixed by the pioneers Nicéphore Niépce, William Henry Fox Talbot and Louis Jacques Mandé Daguerre. In 1839 the processes of these three pioneers were publicly disclosed: photography was born.

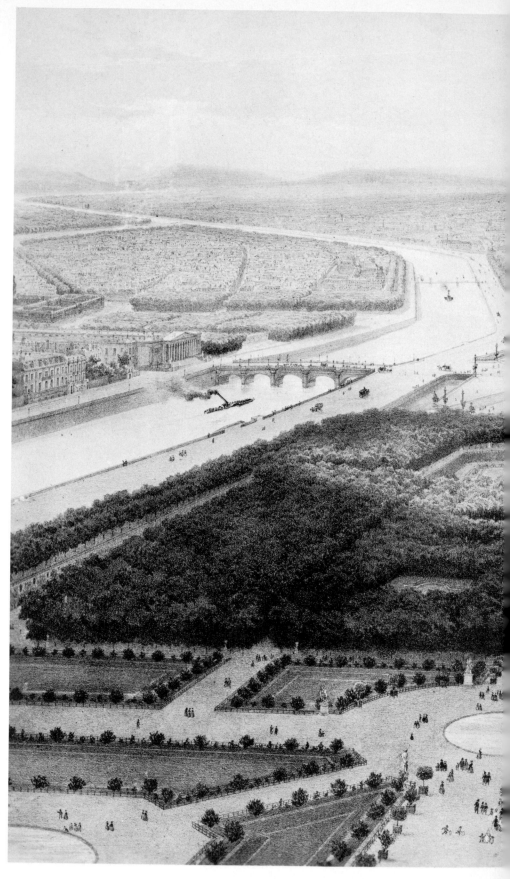

Paris from a balloon. Lithograph by
Lemercier from a drawing by Jules Arnout,
1846.

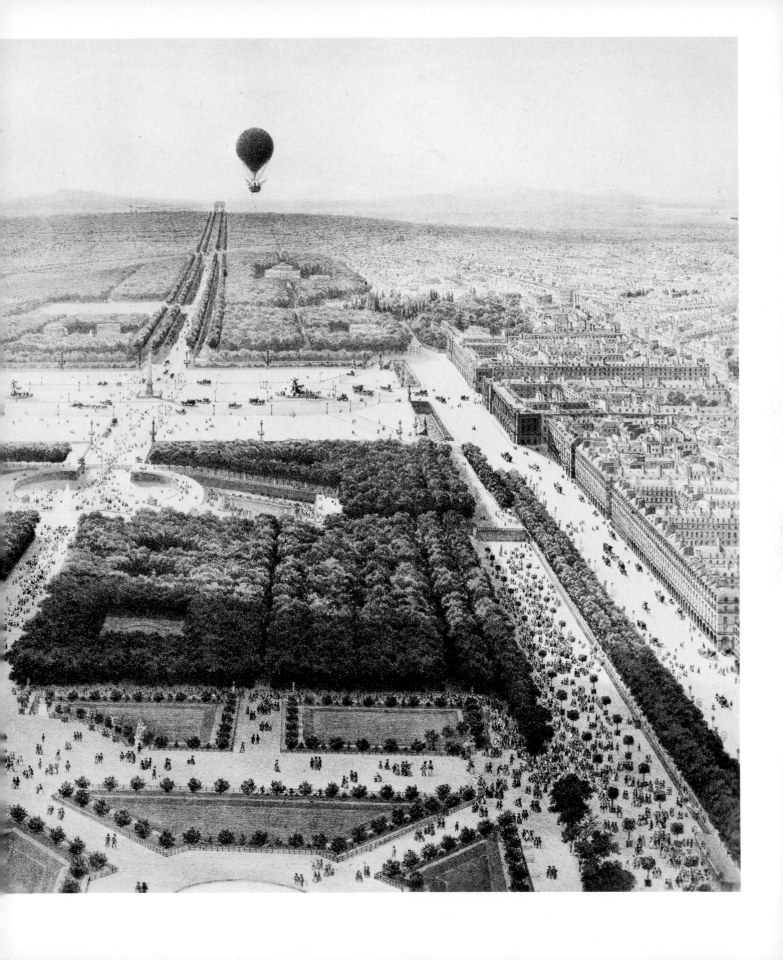

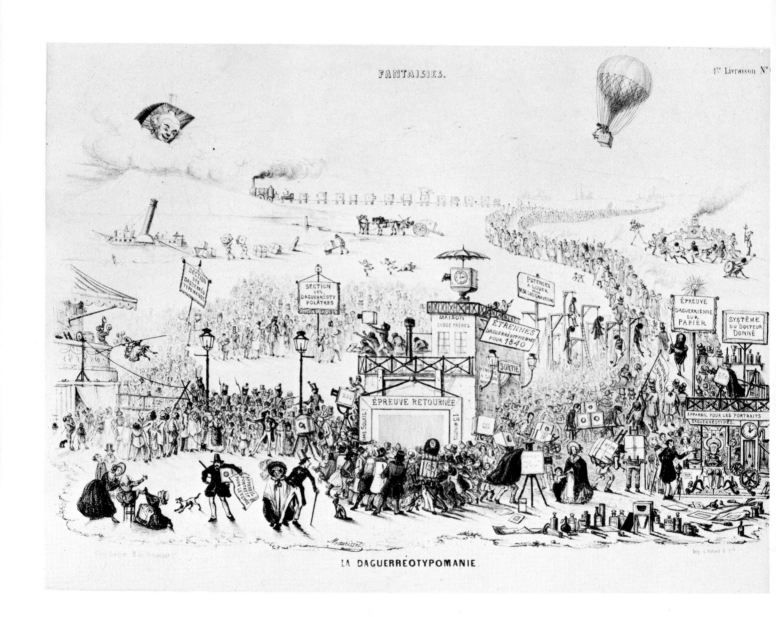

"Daguerréotypomanie." Lithograph by
Théodore Maurisset, 1839.

# 2 THE CAMERA IS AIRBORNE

Aerial photography was prophesied in 1839, when a Parisian lithographer, Théodore Maurisset, recorded the furor and the excitement over photography's birth in a caricature, which he titled "Daguerréotypomanie." Everywhere people are photographing, or being photographed. The threat of the automation of image making has led some to hang themselves in despair on gallows marked "For Rent to MM. the Engravers." To the tune of a violin, figures dance in ritual celebration around the fuming mercury pot used for developing the silvered copper plates. An immense cortege marches towards the horizon. And over all the scene soars a balloon, its car an enormous camera, ridden by a figure who is in the act of uncapping the lens.

Twelve years later a wood-engraving of London was published for sale to visitors to the Great Exhibition of 1851, titled "A Balloon View of London Taken by the Daguerreotype Process." It is hardly likely that photography was used to produce it: the perspective belies its alleged camera origin, for the heights of prominent monuments and towers, which to the earthbound eye seem immense, have been exaggerated. But there is a technical reason why it is most unlikely that "The Balloon View of London" was made from daguerreotypes. At best, that process required exposures of a few seconds. The balloon car is a poor camera platform. Even when it is not rotating and gyrating, it trembles: the slightest motion of the passengers, the laying of a hand upon the railing of the basket, causes it to vibrate. A photographic technique requiring shorter exposures than the daguerreotype was required. This was furnished by the collodion or wet plate process, invented in 1851 by the Englishman, Frederick Scott Archer.

The photographer had to make the plates himself. Immediately before exposure he coated one side of a glass plate with collodion, to which a soluble halide salt such as potassium iodide had been added. In darkness he plunged the still tacky plate into a solution of silver nitrate. A chemical reaction immediately took place: the silver ions and the iodine ions joined to form light-sensitive silver iodide molecules in crystals suspended in the collodion film. The potassium and nitrate ions formed potassium nitrate, which remained in solution. The plate had to be developed while the collodion was moist because when it dried it became a plastic coating that was waterproof, and the developing and fixing solutions could not penetrate to the exposed silver halides. Consequently all manipulations — sensitizing, exposure, and development in iron sulfate — had to be accomplished within twenty minutes. This meant that wherever the photographer worked he had to have a darkroom immediately available. In the field photographers pitched darktents, or dragged around hand carts fitted out as darkrooms, or worked inside horsedrawn vans. To photograph from the air by this process, a darkroom and all the gear, including a supply of water, had to be fitted somehow into the car of a balloon.

The first to try to photograph from a balloon was the Parisian photographer Gaspard Félix Tournachon, who called himself Nadar. A caricaturist, a publisher of humorous magazines, a *bon vivant*, Nadar took up portrait photography in 1853. His studio became celebrated, and his series of striking portraits of intellectual and political leaders of France are a rich heritage. In 1857 he made his first ascent in a balloon owned by the leading French aeronauts Louis Godard and his brother, Jules. From that moment he became a passionate balloonist. On October 23, 1858,

"A Balloon View of London, taken by the Daguerreotype Process." Wood-engraving, published by Appleyard and Hetling, London, about 1851.

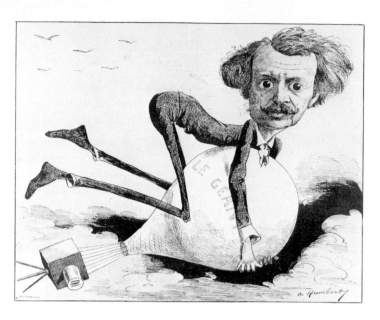

Nadar and his camera balloon. Lithograph by A. Humbert.

he applied for a patent for what we now call air survey: the mapping of the land from a series of overlapping aerial photographs. By the end of the month he resolved to attempt photography. *Le Monde Illustré* announced on October 30, 1858:

### PHOTOGRAPHY IN THE AIR

Photography makes new progress every day; it continues to work marvels. Yesterday it gave scientists beautifully enlarged images of the stars. Today, the image of a bullet, caught in full flight. What will it do tomorrow? M. Nadar, who has played such a large part in these discoveries, has promised to let us know. But we have to wait a few days; his balloon is being readied. From high in the sky he will make striking photographs of lakes, landscapes, forests — our scenery and our cities. We have had bird's-eye views seen by the mind's eye imperfectly; now we will have nothing less than the tracings of nature herself, reflected on the plate. This is the great preoccupation of science and art today.

Nadar made the basket of a balloon he had hired from the Godard brothers into a darkroom. "From the balloon's hoop," he wrote in his autobiography, *Quand j'étais photographe*, "is hung the tent, proof against the least ray of light, with its double orange and black envelope and its little skylight of non-actinic yellow glass which gives me just enough light. It is hot inside it, for the operator and the operations. But our collodion and other chemicals are unaware of that, for they are plunged in baths of ice. . . . My lens, fastened vertically, is a Dallmeyer . . . The shutter which I invented to uncap it and cap it instantly works impeccably. . . .

"At last all is ready!
"I go up.

"What the world is like from a balloon." Wood-engraving from a drawing by Nadar.

"First ascension: result zero!

"Second ascension: result nothing!

"Third ascension: result nil!

"I go up again, and again, and yet again, always, with no result."

Nadar was perplexed and baffled. He continued without success, almost exhausting his funds, for each flight cost dearly.

On one flight at the end of December he came down with one of the Godard brothers on the outskirts of Paris, the Val de Bièvre. Just as the aeronaut started to deflate the balloon and pack it up, Nadar cried:

"Stop! I've just had an idea. Why can't I try again tomorrow morning . . .? The expenses have been met, the gas paid for, and with the neck of the balloon closed there is no danger that the gas will escape by expansion during the night, because already it is chilly. I'm going to leave the balloon right here, well anchored to this stout apple tree, and as an extra precaution fill the car full of millstones and send my assistant to Paris to bring me fresh materials."

Next morning he hardly recognized the balloon, it was so deflated. Most of the gas had escaped, but there was enough, he thought, to make an ascension if he could lighten the load. He took out the darktent, improvised a darkroom in the inn, and sensitized a plate there. He rushed back to the balloon. But it would not rise. He detached the car and climbed onto the hoop. "Then, even though it is chilly, I take off my overcoat, which I throw on the ground, then my vest, then my shoes . . . I unballast myself of everything that can weigh me down and finally I rise, to about 80 meters. I open and close my lens and I shout impatiently:

"Descend!

"They pull me down to the earth. With one leap I dash into the inn where, trembling, I develop my picture. . . .

"Good luck! There is something! . . .

"I urge, I force: the image appears little by little, very weak, very pale. But sharp, definite.

"I triumphantly leave my improvised darkroom.

"It is nothing but a simple glass positive, very weak because of the smoky atmosphere, stained after so many vicissitudes, but no matter! It cannot be denied: here right under me are all of the three houses in the little village: the farm, the inn and the police station . . . You can distinguish perfectly a delivery van on the road whose driver has stopped short before the balloon, and on the roof-tiles two white pigeons who have just landed there.

"Thus I was right!"

Nadar correctly reasoned that his first attempts had failed because he sensitized his collodion plates while airborne, and hydrogen sulfide present in the coal gas escaping from the balloon desensitized his plates: "The merest student of photography would jump at the thought of the pretty combination my iodides would make with the gas, that devil." He said that the gas "vomited forth in a torrent" during flight. This was a normal phenomenon, for as the balloon rises, the gas within the envelope expands. Were it not allowed to escape through the open neck of the envelope, the balloon would burst.

The world's first aerial photograph does not exist. It was but a crude beginning; Nadar himself referred to it as "a simple positive upon glass," made with "detestable materials." But 262 feet over the valley of Bièvre, in 1858, aerial photography was born.

# 3 BOSTON "AS THE EAGLE AND THE WILD GOOSE SEE IT"

In 1859, a year after Nadar's partial success, an American attempted to take photographs from a balloon. He met with utter frustration, for he never got his camera in the air. His last name was Kuhns, and he was said to be a New York photographer, but his name does not appear in business directories and all we know of him is that he arranged with the aeronaut John Wise to set up a portable darkroom, specially built for the purpose, in the car of the balloon *Atlantic*. He arrived at Hamilton Park, ready to go. According to the *American Journal of Photography*, Wise asked him to wait while he took up seven passengers, mostly newspaper reporters. They ascended two thousand feet, "and the delighted party were looking down upon the most fascinating spectacle that had ever been presented to their view. Mr. Kuhns below was waiting eagerly and impatiently for his chance which should come next. The order was given for the descent of the balloon, and it was hauled down rapidly by means of the windlass. The photographer had everything in readiness for his work, and it seemed there was no reason to fear a disappointment, when by a sudden freak of the wind the whole project was ruined; while the party were getting ready to disembark, an unexpected gust of wind carried the balloon against the limbs of a tree, the fabric was rent like paper, and from the escape of gas the whole machine collapsed. No balloon photography that day.

"The next morning . . . thunder and lightning and a deluge of rain claimed the supremacy of the sky.

"On the third day nature made no objection to the experiment . . . The hopeful photographer bending under the load of his specially prepared apparatus was about to step into the car — and — everything was ruined again. Professor Wise had unfortunately become involved in some of the snares of lawyers, and they had taken that opportunity to molest him and enjoin his operations."

The second American to attempt to take photographs from a balloon, James Wallace Black of Boston, succeeded

beautifully. Indeed, aerial photography as a practical technique may be said to date from October 13, 1860, when he photographed downtown Boston from an altitude of 1,200 feet.

The initiative was not his, but that of a dentist from Providence, Rhode Island, Dr. William H. Helme. Ballooning was extremely popular in America: it was estimated that between 1809 and 1859 more than three thousand ascensions had been made. They were favorite holiday events all around the nation. On the Fourth of July of 1860, three balloons were inflated on Boston Common: *The Belle of New England*, E. S. Allen, aeronaut, *The Queen of the Air*, Samuel Archer King, aeronaut, and *The Zephyrus*, owned by both King and Allen. Dr. Helme persuaded the aeronauts to allow him to make a solo ascension in *The Zephyrus*. It was his first flight. "The balloon went up to a great altitude, estimated from two to three miles," the *Boston Journal* reported. "Taking a course successively over Cambridge, Roxbury, Dorchester, Quincy and Milton, it was visible to the multitude for a long time. It finally landed in the meadow of Mr. S. P. Mack, at Mattapan, Dorchester, who spared no pains in entertaining the unexpected visitor. . . . Dr. Helme returned to Boston at a late hour last evening, and expressed himself highly delighted with his aerial voyage."

While he was in the air, Helme began to reflect on the uses to which a balloon might be put. "I wondered greatly that scientific men have not resorted to the use of balloons for the solution of problems as yet unsolved," he recollected. "What eminent meteorologist ever ascended to the regions of the 'upper deep' in a storm, to witness the phenomenon from above, or even in calmer periods to study the clouds or currents of air from a convenient position among them? . . . The idea that it was possible to get photographic pictures of the appearance of the earth grew into a conviction when I thought of the wonderful success of the art in taking street scenes of moving objects in a strong sunlight, by the instan-

taneous opening and closing of the light upon the sensitive plate of the camera."

He resolved to undertake the experiment. Friends and other citizens of Providence raised funds, and at the advice of "an eminent scientist" he invited Black to attempt to photograph Providence from the air. Black replied at once that he was "ready and willing to come to Providence any number of times for a bare chance of success."

The instantaneous photographs which led Dr. Helme to believe that photography was possible from the air were recent triumphs of the art. The average exposure of the standard wet plate was measured in seconds even on a bright, sunny day. This meant that moving objects were either not recorded at all, or appeared as vague, ghost-like forms. But in 1859 in Scotland, England, France, and America, photographers independently began to find it possible to take, with twin lens cameras, stereoscopic views of city streets recording, with remarkable detail, pedestrians, horse-drawn vehicles and even windblown flags. Known as "Instantaneous Views," they were most popular in this period when the stereoscope was a parlor fixture throughout the land. Oliver Wendell Holmes, himself a photographer (he was a pupil of Black's) and the inventor of the classic hand stereoscope with hooded lenses and sliding frame to hold the double-views, marvelled at "Mr. Anthony's* miraculous instantaneous view in Broadway. . . . It is the Oriental story of the petrified city made real to our eyes. . . . Every foot is caught in its movement with such suddenness that it shows as clearly as if quite still. . . .What a wonder it is, this snatch at the central life of a mighty city as it rushed by in all its multitudinous complexity of movement! Hundreds of objects in this picture could be identified in a court of law by their owners. . . . What a fearfully suggestive picture! It is a leaf torn from the book of God's recording angel."

Black made two ascents with Helme in *The Queen of the Air* over Providence, "while the balloon was confined by a cable to an elevation of twelve hundred feet over the new made grounds above the Park." He did not get a single photograph. The reason: "want of sunlight."

He tried again in October, from the balloon *Jupiter*, lent by John Wise, "to whom the art of aeronautics is more indebted, in this country, at least, than to all others together." The flight was disastrous. On landing near Newton, New Hampshire, a gust of wind ripped the gas bag from the car, blew it away, and the balloon was destroyed.

Undaunted, Helme and Black went to Boston, where King now had his balloon *The Queen of the Air*. Two ascensions, one captive and one free, were made by King and Black over Boston on Saturday, October 13. King described them in the *Boston Journal*:

"First of all, we arose 1,200 feet, by means of a stout rope attached to a windlass, and while remaining stationary at this height, succeeded in getting some fine views of different parts of Boston.

"But we wished to get more extended views than could be obtained at such a height, and so after being drawn down, and detaching the rope, we ascended in the usual manner. Soon an expansive field was opened to us, and we hoped to be able to secure some magnificent scenes which now we scanned. Everything was in readiness, and an attempt was made to take the city, that was now sitting so beautifully for her picture. But just at this time we encountered a difficulty which had never before suggested itself. The gas expanding as the balloon rose flowed freely from the neck, and filled the surrounding atmosphere, penetrating even into the camera, neutralizing the effect of the light, and turning the coating on the glass plate to a uniform dark brown color. Several plates were spoiled in this manner before we discovered the cause; by which we lost much very precious time, as we were rapidly drifting away in a southerly direction. Soon after, the balloon reached an altitude above the clouds, which were already quite numerous, and gathering fast. For some mo-

---

* Edward Anthony, pioneer photographer, proprietor with his brother Henry Thiebout Anthony of the firm E. & H. T. Anthony, America's largest dealers in photographic materials and publishers of photographs.

"Bird's-eye View of Boston." Lithograph by John Bachmann, 1850.

Samuel A. King, pilot of *The Queen of the Air,* was also a photographer — but land-based in a Boston studio.

ments we lost sight of the city and its surroundings, and when we again descended below the mist, our distance from Boston was too great to make it worth while trying to get any more views of that locality.

"We were nearing the coast in an oblique direction, and as our voyage must consequently be of short duration, it was necessary that our movements should be very rapid. Mr. Black proved himself to be peculiarly fitted for the object we had undertaken. Entirely absorbed in his manipulation, he worked with a celerity that was truly astonishing, and never allowing the novelty of the scene to divert his attention for a moment when there was an opportunity for securing a picture.

"In this way we moved along sometimes taking views immediately beneath us, and at others bringing into focus objects that were miles away. None of these views were equal to those taken while hovering over the city, for the clouds had now gathered thick in every direction, and an intervening mistiness in the atmosphere prevented the impressions from being clearly defined.

"Our last attempt at photographing was just after passing over the village of East Weymouth. Finding it impossible to carry our experiments any further, the apparatus was secured, the tent dropped, and the balance of the voyage was devoted to pleasure."

One of the photographs has survived in two versions. The American Museum of Photography in Philadelphia owns a copy negative made from a print which was trimmed to an oval format; the print we reproduce was made from it. The Musée de l'Air, Paris, owns an uncropped rectangular print; the corners lack detail, due to poor lens coverage and difficulty in coating the plate.

Oliver Wendell Holmes described this photograph in *The Atlantic Monthly*, July, 1863:

"Boston, as the eagle and the wild goose see it, is a very different object from the same place as the solid citizen

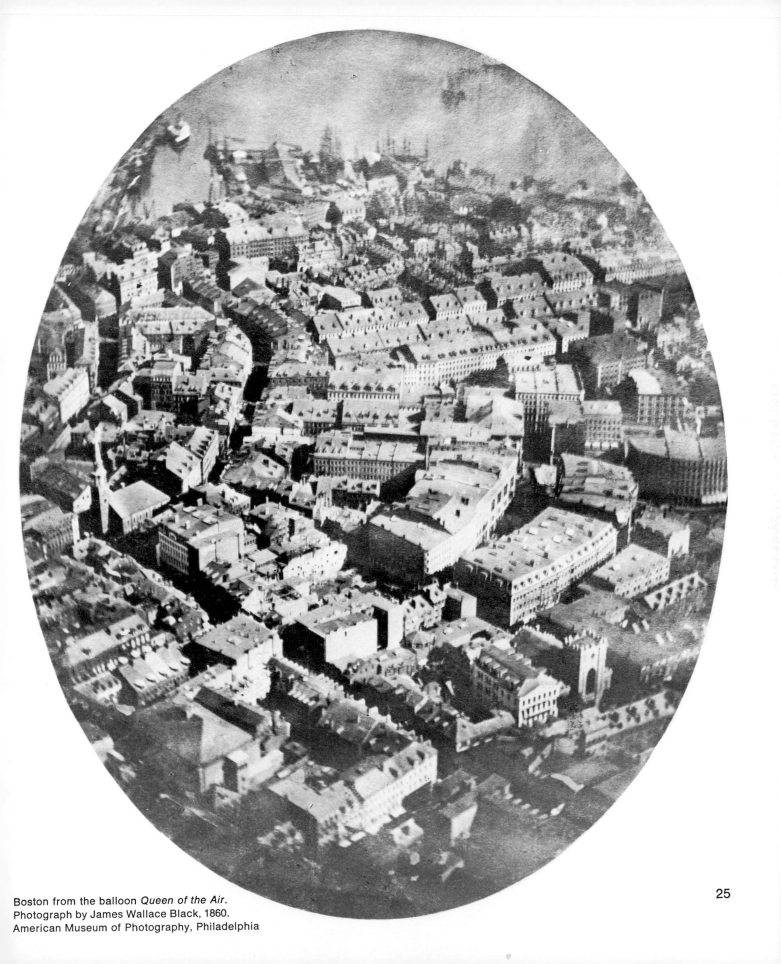

Boston from the balloon *Queen of the Air*.
Photograph by James Wallace Black, 1860.
American Museum of Photography, Philadelphia

25

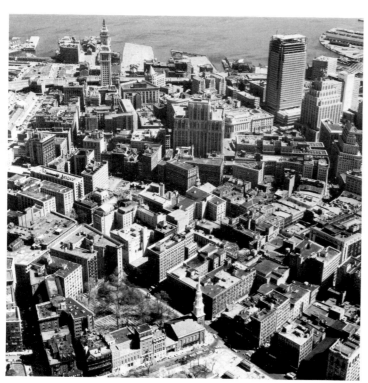

Boston in 1965. Photograph by William J. Hannon for New England Survey Service, Inc., Boston.

looks up at its eaves and chimneys. The Old South and Trinity Church are two landmarks not to be mistaken. Washington Street slants across the picture as a narrow cleft. Milk Street winds as if the cowpath which gave it a name had been followed by the builders of its commercial palaces. Windows, chimneys, and skylights attract the eye in the central parts of the view, exquisitely defined, bewildering in numbers. Towards the circumference it grows darker, becoming clouded and confused, and at one end a black expanse of waveless water is whitened by the nebulous outline of flitting sails. As a first attempt it is on the whole a remarkable success; but its greatest interest is in showing what we may hope to see accomplished in the same direction."

His description is an *interpretation*. Knowing Boston, he has identified the principal landmarks. The information contained in an airview is not always obvious: the earth, and what man has built upon it, have a quite different look from above. Some features are easy to identify; others must be puzzled out. The photo interpreter relies greatly upon comparisons. The New England Aero Service kindly made for us in 1965 a photograph of the same area of Boston as shown in Black's 1860 photograph, from approximately the same altitude (1200 ft.) and the same azimuth bearing. We cannot imagine a more graphic demonstration of the growth of a city in a century. Of the two landmarks pointed out by Holmes, the Old South church is the only building which appears in both photographs. All else has changed.

# 4 THE CAMERA REACHES NEW HEIGHTS

On December 3, 1858, the editor of *The Photographic News*, noting Nadar's first balloon photograph, stated: "Balloons have been, as is known, employed for purposes of strategy during the wars in Germany, Belgium, and Egypt. Photography, hereafter aerostatic, may render great services in the taking of ground plans, hydrography, etc. There is no necessity for us to insist upon the importance of this scientific event." Six months later the editor reported: "Nadar has been sent for by headquarters for a particular mission; and perhaps at the present moment photography, represented by him, floats in a balloon over the field of battle, for the purpose of depicting the manoeuvres of the enemy."

The report was premature: Nadar had, indeed, been approached by one M. Prevot, "a business man," with the offer of a large sum of money to undertake balloon photography for the French army in Italy, but he turned it down because trials made in May, 1859 were unsuccessful.

When hostilities began between the North and the South in the United States, James Wallace Black wrote to the *New York Tribune*, suggesting the use of air photography for military reconnaissance and sent photographs to the Topographic Engineers. Under this division of the Union army Thaddeus S. C. Lowe had begun reconnaissance from the balloon *Intrepid*. He had devised what he called an "aerial telegraph," which operated by electric current supplied by wires in the cables of the balloon. Lowe reported his observations by reference to a gridded map, a duplicate of which was on the ground. On at least one occasion, a scaled and annotated drawing of enemy terrain was made.

It was obvious to photographers that camera pictures would be more valuable than drawings. The American Photographical Society discussed the problem, and the president, John William Draper, wrote to the Secretary of War on June 10, 1861 offering the Society's services. No answer was received. There is no evidence that any action was taken on the suggestion. It has been stated over and over again that aerial photographs were taken during the Civil War. If they were, none is to be found in any archive; nor is there any contemporary evidence that they were made. A detailed report on *Balloon Reconnaissance as Practiced by the American Army* was made to the British Royal Engineers in 1862 by Captain F. Beaumont. Although he described Prof. Lowe's operation in detail, including the aerial telegraph, he does not have a word to say about photography. Until further evidence materializes, it cannot be said that cameras were airborne by either the Union or Confederate balloon corps during the war of 1861-1865.

At this time in England, a series of remarkable ascents were being made by the aeronaut Henry Coxwell in his balloon *Mammoth*. Under the sponsorship of the British Association for the Advancement of Science, he took James Glaisher, Chief of the Meteorological Department of the Greenwich Observatory and Vice President of the Photographic Society of London* to new heights. Glaisher's purpose was "the determination of the temperature of the air, and its hygrometrical states, at different elevations, as high as possible." Their most famous flight was on September 5, 1862 when the scientist and the aeronaut rose higher than they had intended. Glaisher fell unconscious for lack of oxygen; Coxwell's hands froze; and he was barely able to pull the valve-line with his teeth to release gas so that they would descend. Glaisher estimated that the balloon rose to 36,000 feet. By today's knowledge of the physiological effects of high altitude such a claim is untenable; the barometer which served as altimeter may have malfunctioned, or was incorrectly read under stress.

On another high-altitude ascension, June 3, 1863, Coxwell and Glaisher took along a camera. They ascended to "about four miles and a quarter" in 52 minutes, shooting up at a speed which surprised them through three different layers of clouds and a snowstorm. But they could not photograph because of the "thick atmosphere and large amount of vapor."

* Since 1894 the Royal Photographic Society of Great Britain.

Civil War reconnaissance sketch, drawn from a balloon by Col. Wm. F. Small, 1861.

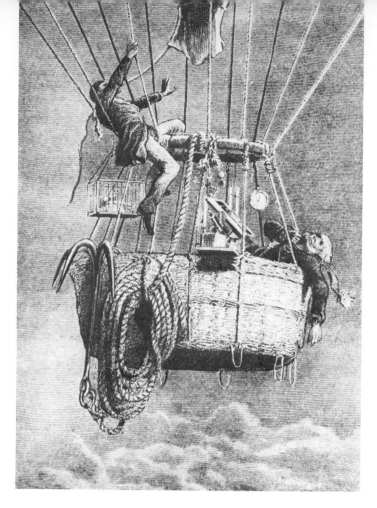

The perilous balloon ascent of Henry Coxwell and James Glaisher, 1862.

* The word "actinic" was coined by Sir John Herschel in 1840 to describe that portion of the visible and invisible spectrum to which the sensitivity of photographic materials was then limited, ranging from blue to ultraviolet. The word became obsolete upon the discovery by Hermann Wilhelm Vogel in 1873 that photographic materials can be made sensitive to all radiation.

Coxwell made a more successful photographic ascent with Henry Negretti, a London scientific instrument maker, and his assistant in 1863. Negretti gave an account of it to *The Daily News*: "The car was fitted up as a dark room (as I had resolved upon employing the wet collodion process), the cameras were fixed, a plate had been prepared by my assistant (Mr. Collings), and about twelve o'clock on Thursday last we started from the gasworks at Bell-green, Lower Sydenham, and proceeded in a south-easterly direction. We rose rapidly from the ground, so as to clear the chimneys of the gasworks; and this swift ascent caused the balloon to revolve so quickly at first that it would have been useless to expose the plate which we had prepared. This rotary motion of the balloon continued more or less throughout the whole journey; and it constitutes indeed the most serious obstacle with which the photographer has to contend. In about a quarter of an hour, and at an altitude of nearly 4,000 ft., as registered by a small pocket barometer, the car became much more stationary, and accordingly I now determined upon taking a picture. The exposure was almost instantaneous; but the brief period that elapsed between pouring on the developing solution and the appearance of the image was to me one of the most anxious suspense; the problem of the actinic* or non-actinic properties of light at such an altitude was to be solved, and it was with some pardonable degree of exultation that I heard my assistant say 'the picture has moved' (which, for the information of the non-photographic reader, means that there was a picture, but not a good one, owing to some movement in the object to be photographed, or in the apparatus). On hearing the above I was greatly relieved, and said 'All right! Prepare another.'" Again and again the exposed plates showed motion. "I had focussed a lovely park and mansion, when, to my chagrin, I saw the picture leave the ground glass. I wished to see it again, and took hold of one of the ropes that suspends the car to the balloon, and by successive 'pullings' at the rope succeeded in jerking the

view back again, but, of course, by so doing I had imparted a movement to the balloon that prevented me doing anything further for some time. The main object of what was essentially an experimental trip had been obtained, and it had been demonstrated that photographic views can be taken at an elevation ranging from 3,000 to 6,000 feet from the ground."

The *Daily Telegraph* reported that the pictures were "tolerable. . . . The net result of Mr. Negretti's aerial essay is . . . an establishment of the fact that photography is just as feasable an idea 5,000 feet above the level of the sea as in a commodious glass house in Regent Street or the Champs Elysées. The beautiful valley of the Medway has not been flattered by its *carte de visite*, taken in the car of the mammoth balloon; but, on another sitting, its fair face may possibly 'come out' more truthfully charming in the novel exposition of its loveliness." Unfortunately, we have not been able to locate these photographs.

Negretti was overwhelmed with advice by letterwriters, who suggested that the camera could be held more steadily if a rudder was attached to the car of the balloon, or the camera itself mounted on a gyroscope. He pointed out to these eager critics that a rudder would make the balloon even more unsteady, and that a gyroscope of proper size to function would "weigh several hundredweights, and would take the united exertions of three or four persons to set it in motion. I need not say that I never could hope to adopt this plan. No Sir; if photography is to be done from a balloon, the photographer must mainly depend on having suitable and appropriate apparatus for keeping his camera freely and steadily balanced, on skill in manipulation, the rapidity with which he can expose the sensitive plate, and judgment in seizing the right moment for exposure, for there are moments when there is only a progressive movement, which, if towards or leaving an object even at the rate of 15 or 20 miles an hour, every photographer knows we care very little about.

"Messrs. Nadar and Godard did, in 1858, try to take photographs from a balloon fastened to the ground with ropes, but even with the balloon in this captive state, they did not succeed in obtaining sufficient steadiness for their purpose. Photography has made wonderful progress since then, and for all that, is still in its infancy. Up to the present time I believe I am the first person who has ever taken a photograph from a free balloon. What now seems a difficult matter will be eventually a very simple affair, and in my present task I am only attempting to forestall the regular course of events."

The newspaper article was reprinted in *The Photographic News* with the comment: "Mr. Negretti here overlooks the fact that some successful experiments in photography from a balloon have been made in the United States. In the year 1860 Mr. Black ascended from Boston, and exposed six plates. Of these two were stated to have been very successful. The results were shown to the American Photographic Society, and described as clear and sharply defined, giving a view very similar to that seen by the aeronauts." Nadar also protested: "M. Negretti, the celebrated optician of London, has obtained this year, according to what has been stated, some beautiful negatives, of which it affords me great pleasure to hear, since it has ended in demonstrating experimentally that *I was right*. I shall only permit myself to observe to M. Negretti, that he deceives himself in claiming priority. The dates of my patents prove it, on the one hand; and besides, I have myself obtained, in spite of most detestable materials, results (a simple positive upon glass, it is true), above the valley of the Bièvre, at the beginning of the winter in 1858. If I have not made any claim against the assertions contained in the two letters of MM. Simon of the Greenwich Observatory, and Negretti, published successively in the 'Daily Telegraph', it is only because I had not time. But I do not at all mean that there should be prescription in that case."

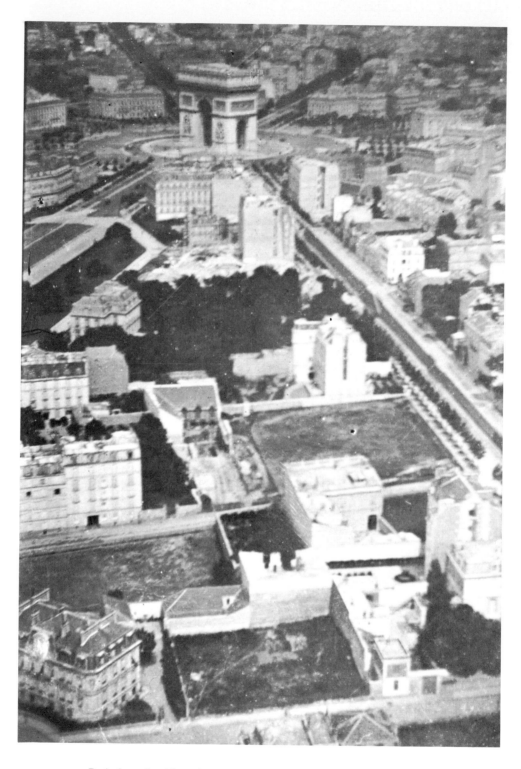

Paris from the Hippodrome Balloon. Photographed by Nadar, 1867.
Enlargement of one frame of the original negative. (See p. 33.)

# 5  NADAR PHOTOGRAPHS PARIS

Nadar, now completely absorbed in the challenge of flight, was convinced that the future of air travel no longer lay with the balloon, but with the airplane, which even then existed in the form of a model helicopter which actually flew. He wrote:

"To contend against the air, one must be specifically heavier than the air.

All that is not absurd is possible;

All that is possible may be accomplished."

On July 30, 1863 he invited the inventor of the model, Viscount de Ponton Amécourt, to demonstrate it in his photographic studio. At this meeting a society was formed "for the encouragement of aerial locomotion by means of machines heavier than air." Besides Nadar and the Viscount, its members included another aviation enthusiast, Gabrielle de la Landelle, the writers George Sand, Alexandre Dumas and his son, Jules Verne, and others. Nadar founded a magazine, *L'Aéronaute*, and proposed to raise funds by building a spectacular monster balloon, which he named *Le Géant*. *The Giant* was thus intended to be the balloon to end all balloons. Although it was not the largest balloon — that record belongs to *The City of New York* which burst on an attempt to cross the Atlantic Ocean — *Le Géant* was three times the size of an ordinary balloon. It held 210,000 cubic feet of gas. Its car was mammoth, "a regular two story house," fitted with three-decker beds for twelve passengers, a photographic darkroom, a printing press, and even a lavatory. "We are not about to amuse ourselves, as one may suppose, in making portraits in the air," Nadar wrote. "The balloon *Le Géant* will be employed in various aerostatic photography, for which I was the first to take patents in France and abroad seven years ago, and the results of which will be so valuable for all planispheric, cadastral, strategical, and other surveys."

"The last balloon," as Nadar called it, almost cost him his life. The second ascension began from the Champ de Mars,

Paris, on October 18, 1863, with nine passengers aboard, including Mme. Nadar and the professional balloonist Jules Godard. The wind took them eastward, toward Belgium. During the night, when they were over Hanover, Nadar mistakenly thought he saw the ocean close by. Fearful that they might be blown out to sea, he panicked and pulled the valve-line. It broke, and they descended abruptly while the balloon was partly inflated. Jules Godard desperately slashed the envelope, but it was too late: the balloon became an enormous parachute which was blown by the gale not to sea, but across some twenty-five miles of country. What

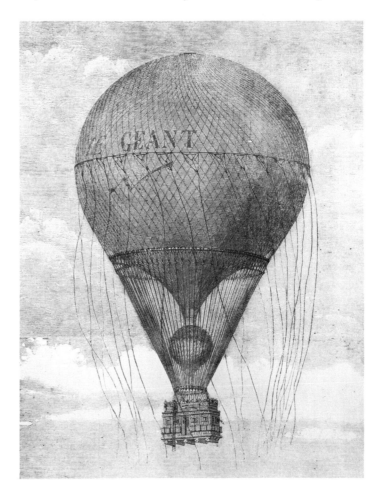

Nadar's balloon *Le Géant*.

Paris from the Hippodrome Balloon. Photographed by Nadar, 1868. Contact print from the original collodion negative, exposed in a multi-lens camera.

Nadar had thought to be the ocean was a cloud bank. It was a miracle that the passengers were not killed as the enormous car bumped over the ground. Nadar and his wife were seriously injured.

There is no record of any photographs having been taken from *Le Géant* on the seven ascensions Nadar made in it. The project was a financial disaster. Nadar could not make the final payment to the Godard brothers who built the balloon and they threatened suit; he was forced to sell it in 1867.

But the next year Nadar was again airborne with his camera, and in July he made a number of photographs of Paris from the Hippodrome Balloon, held captive over Paris at 1,700 feet.

The editor of *Le Petit Figaro* saw Nadar land. "He was glowing, transfigured. He waved his negative in the air, shouting: 'Eureka!' . . ."

Actually Nadar made more than one negative, for two glass plates exist in the Archives Photographiques of the Caisse Nationale des Monuments Historiques in Paris, each containing eight exposures. They are identical to carte-de-visite plates, made with a multilens camera. Nadar used this camera to multiply his chances of success; it was fortunate he did, for only two of the exposures were successful.

A wood-engraving of the best of them, showing the Arc de Triomphe in the distance, appeared in *Le Petit Figaro* in its July 31, 1868 issue. The names of the boulevards are printed beside the picture, so that the readers could identify the scene. The engraving is not only the first reproduction in a magazine of an aerial photograph, but the first one to be annotated.

Nadar continued to photograph from the air and during the siege of Paris in 1870 he was in charge of the balloon corps. But he added nothing to the technology of aerial photography.

# 6  THE BALLOON CAMERA BECOMES AUTOMATIC

It soon became obvious that there was no need for the photographer to go aloft: only the camera need be airborne. In 1862 Karl Gunther described such a system at a meeting of the Photographic Society of Vienna: to a small, unmanned captive balloon was attached a camera, fitted with a shutter which could be released by electric current supplied by wires in the tethering cable. We do not know if the system was ever put to use, nor if a similar camera, with the resounding name *Ophthalmos*, was actually airborne. It was patented in the United States by Reverend John A. Scott in 1869. The camera was in the form of a cylinder, with the lens at the bottom and a clock at the top. Between the clock and the focal plane was a compass. At a predetermined time, mechanism was set in action by the clock to release the shutter in front of the lens, and to drop a mesh onto the compass needle, thus holding it fixed at the bearing assumed by *Ophthalmos* at the moment of exposure. At the same time a flag attached to the instrument was released to indicate that the exposure had been made. The balloon was then drawn down, the plate removed "and treated as all plates are that are taken upon or under the earth." *Ophthalmos* held but a single, circular plate.

A more sophisticated balloon camera was designed and patented in England by Walter Bentley Woodbury in 1877. It weighed only 12 pounds. Like Gunther's, the shutter was released on command from the ground by electric current supplied by wires in the cable. Four plates, fastened to the faces of a cube, were brought in position in the focal plane one after the other by a second electric circuit. The entire gear, Woodbury told the members of the Balloon Society of Great Britain, was carried about in a hand cart "like those used by bakers in London suburbs." An important piece of equipment, Woodbury stated, was a small telescope through which he observed the gyrations of the balloon and the position of the camera. When it was relatively still, and pointing downwards, he pushed one button to release the shutter, and the second button to change the plate.

The plates which Woodbury used were the newly invented gelatino-bromide dry plates, introduced in 1871 by Richard Leach Maddox, a London physician and photomicrographer. He found the conventional collodion process troublesome, especially because of the annoying alcohol and ether fumes released by the collodion in the confined area of the glass studio where he did his work, and proposed gelatin as a medium for suspending light-sensitive silver salts. With the generosity of a true scientist, he published his preliminary experiments in *The British Journal of Photography* with the suggestion that others perfect the process. "So far as can be judged," he wrote, "the process seems quite worth more carefully-conducted experiments, and, if found advantageous, adds another handle to the photographer's wheel." Within a few years gelatin plates were being manufactured in quantity. Their primary advantage over "wet plates" was that they could be developed when the emulsion was dry. Photographers everywhere found, to their surprise and delight, that the new gelatin plates were not only easier to handle, but were more sensitive than anything they had used before.

To the airborne photographer the new plates were a great boon. Never again would he need to crowd a makeshift darkroom into a balloon basket and prepare his plates while gas spewed forth above his head. Furthermore, he could take a large quantity of plates aloft, and could expose them in rapid succession. Since the plates were so sensitive — they were more than 60 times "faster" than collodion — exposures could be made of such brief duration that they were called "instantaneous." The adjective was too inexact for Woodbury; he said it "can only be classed with such unfathomable words as 'space' and 'eternity'. Given what is called 'instantaneous exposure', the same may be divided again into hundredths, thousandths, *ad infinitum*. We can only try and get as near instantaneity as possible, and then still be a long, long way from it. Therefore — as I have said before — the most rapid plates and shutters are of first necessity."

Shutters operating in precise fractions of a second were almost unknown when Woodbury designed his balloon camera. Most of them were simply sliding plates pierced with an aperture the size of the lens. They operated by gravity and were known as "drop shutters." Woodbury's shutter was a revolving disk with four apertures, tensed by a single rubber band. On command from the ground the disk revolved a quarter turn. The shutter had a marked deficiency: "owing to the india-rubber or other spring gradually losing its force, the first exposure will be more rapid, the second less so, the fourth the slowest." Woodbury found this no handicap, for experiments proved to him that exposures varied according to the altitude of the camera. He said, "This deficiency will allow of an equality of exposure being obtained at different heights, the lowest exposure being given the last, when the spring is at its weakest." In his patent Woodbury described an alternative plate changing mechanism: "a roll of sensitive tissue." This was primitive roll film, invented by Leon Warnerke in 1875: he coated paper with rubber, collodion emulsion and gelatin. After exposure the light-sensitive emulsion was developed and stripped from the base. A long roll of this sensitized tissue was put in a special holder he devised to fit inside the camera; thus pictures could be taken one after the other in rapid succession. Warnerke's invention was but one of several predecessors of the roll film system that George Eastman was to make internationally universal within a few years. To Woodbury goes the honor of having envisioned the aerial camera of today, which takes up to 500 9 x 9-inch pictures on a single roll of film. But the primitive stripping film used by Woodbury proved unsatisfactory. "I found that enlargements made from such prepared tissues did not give anything like the delicacy of the ordinary photographic glass plate negative. . . . We must be able to get a good enlargement from our small negative, otherwise it would possess little value."

In 1882 Woodbury wrote the editor of *The Photo-graphic News* that he had abandoned his balloon camera: he "found no likelihood of its being taken up." He was ahead of his time; in 1959 Aero Stills, Ltd., was founded in London by Conrad Nockhold for the purpose of taking photographs from a captive balloon. Nockhold's system is almost identical to Woodbury's: a 2¼ x 3¼-inch camera, suspended beneath a small balloon, is controlled from the ground by electric current carried in the cable. The system is designed for photographing at altitudes of 400 feet or lower in populated areas, where airplanes are prohibited.

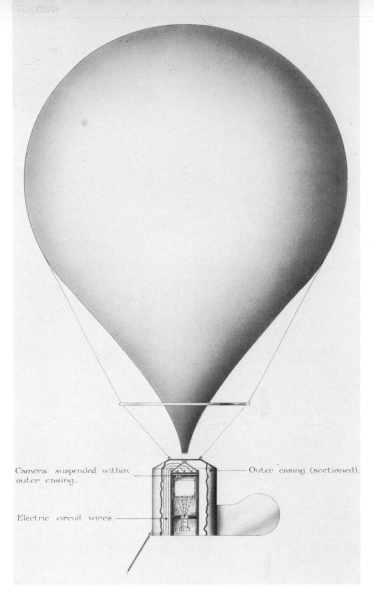

Camera suspended within outer casing.

Outer casing (sectioned).

Electric circuit wires.

Woodbury's automatic camera balloon.

# 7  PHOTOGRAPHING FROM FREE BALLOONS

With the new dry plates and hand cameras, photography was so greatly simplified that almost anyone could take photographs anywhere with no more trouble than pressing a button. Balloon photography, once a tour de force of the professional, now became common. Furthermore, the increased speed of the dry plate, plus its keeping power, made possible the regular use of the camera in the swaying basket of a free balloon. Aerial photography was no longer limited to recording the earth from a tethered balloon; now pictures could be made in flight. There was only the uncertainty of navigation.

The first airman to take dry plates aloft in a free balloon was luckless indeed. M. Triboulet of the Société d'Aérostation Météorologique made a balloon ascent with one Monsieur Joves from Arceuil-Cachan on June 17, 1879: destination, Paris. Triboulet photographed the French capital from 1,640 feet, a record at that time. No sooner had he exposed the plate than the weather changed, and the aeronauts found themselves in a torrential rainstorm. The balloon basket was flooded. Although they bailed furiously, the weight of the water in the car caused the balloon to drop rapidly. They threw out all ballast, but still they dropped until, almost grazing the towers of the cathedral of Notre Dame, they splashed down in the Seine River. They were pulled out, safe and sound, by sailors. At that time the city of Paris had its own custom laws. Alert inspectors, incensed that the aeronauts had entered Paris illegally without going through customs formalities, suspected contraband. They examined everything "with such zeal that they opened the photographic plate holders, to see *what was inside them.* Thus they let light fall on the plates that M. Triboulet had exposed 500 meters above Paris!"

Air cameramen began to perfect their technique, and to demand the utmost sharpness and detail in their photographs. "We must not expect to get artistic pictures so much as plans," Woodbury wrote, and insisted on "an absolutely vertical picture, such as would be necessary to get a correct map of the earth."

Gaston Tissandier, aeronaut, editor of the magazine *La Nature*, and author of the first manual on air photography, *La Photographie en ballon*, praised a group of photographs taken in 1883 from the balloon *Sunbeam* by Cecil V. Shadbolt, England's leading aerial photographer until his untimely death in a balloon accident in 1892. Tissandier particularly praised Shadbolt's photograph of northern London, near Stamford Hill, which so far as we can determine is the earliest true vertical airview in existence. Tissandier analyzed the photograph: "You can clearly distinguish the railroad, and the junction of the Enfield track of the Great Eastern Railway with the Tottenham and Hampstead line. A railroad bridge crossing the road can be seen; its shadow is very clear and gives it remarkable relief. A train in motion, with smoke coming out of the locomotive, can be recognized, and farther on a house, which is of incomparable sharpness. With a magnifying glass you can distinguish, on the original photograph, all its details — chimneys, interior courts, etc. The other parts of the photograph show the roofs of houses lined up with regularity one beside another, their gardens all alike and of the same size, as is the English custom. You can also see, on the left, fields cut up into farms."

Tissandier himself made a photo flight in *Le Commandant Rivière* with Jacques Ducom, a photographer; they took five photographs over Paris on June 19, 1885.

The best of them was taken directly over the tip of the Ile St.-Louis at an altitude of 1,968 feet. Tissandier was entranced by the wealth of information which the negative contained. "When the print is examined through a magnifying glass," he wrote, "you can see unexpected details, such as the coil of rope in a boat moored alongside the swimming bath, pedestrians standing on the quais, etc. On the negative, you can count the chimneys of the houses,

which appear as little black dots." Tissandier reproduced this photograph as the frontispiece to his book. Over it he tipped in a tracing of the photograph printed on thin paper: it is an accurate map of the area.

The vertical airview, at first so strange and puzzling, is the most useful type of aerial photograph for studying the earth and man's activities upon it. Often we can see more than from the ground itself — the interior courtyards of buildings, the open holds of the boats, the curious grating of the swimming baths. And what is even more helpful, we can measure everything with remarkable precision and with far less trouble than on the ground. If we know the exact

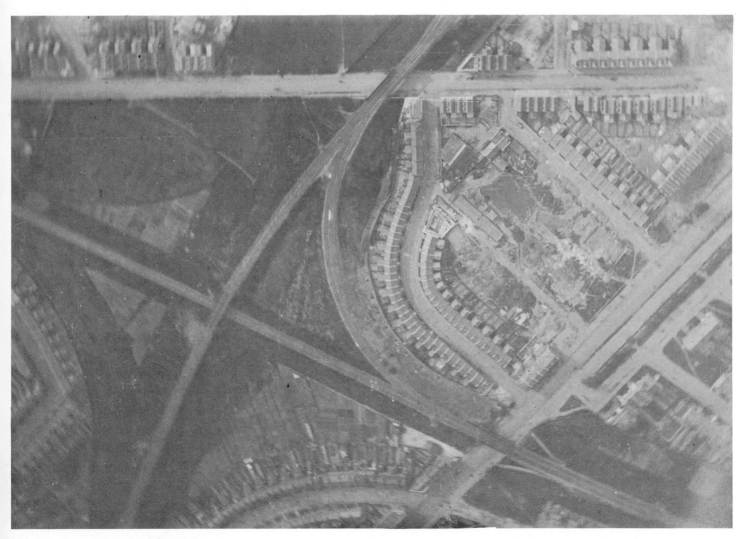

"Instantaneous Map Photograph of district near Stamford Hill, London, N., Taken from the car of a BALLOON at an altitude of 2000 feet, by C. V. Shadbolt, Beechcroft, Chislehurst."

Paris, photographed by Jaques Ducom on June 19,1885, from the balloon *Le Commandant Rivière*, Gaston Tissandier, pilot. At right is the tip of the Ile St-Louis. Moored beside the quai is a swimming bath.

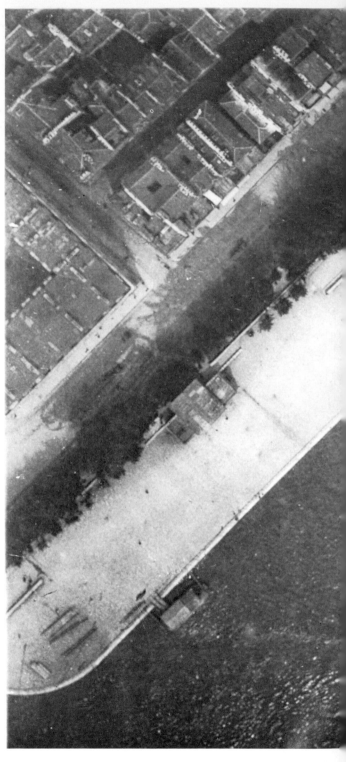

Ducom fastened to the car of the balloon a standard 5x7-inch view camera with a 22-inch rapid rectilinear lens. He exposed a dry plate 1/50 second at f/22.

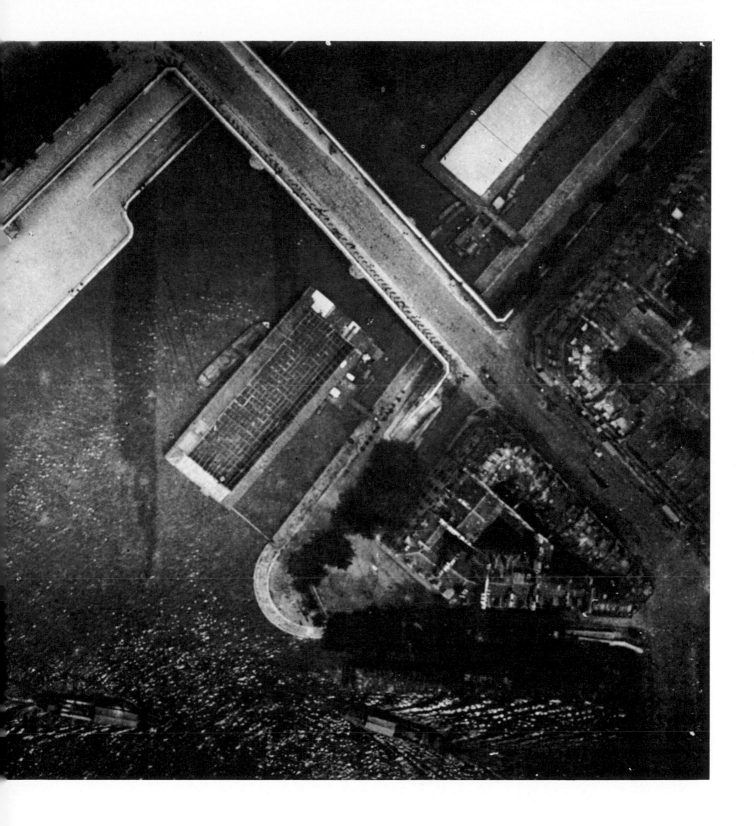

Kite photograph by Arthur Batut,
1889. Altitude, 500 feet.

height of the airborne camera and its focal length, we can calculate the scale of reduction simply by dividing the height by the focal length. In Ducom's photograph the height of the camera was 1968 ft., or 23616 ins., its focal length 22 ins. Dividing 23616 by 22 we have a *scale number* of 1073. Everything in the photograph is $\frac{1}{1073}$ actual size. The image of the boat in the lower right measures 0.67 ins. We have but to multiply this dimension by 1073 to calculate the length of the boat itself: 718.91 ins., or approximately 60 ft.

Tissandier observed that "one could easily have two or three cameras in the car of the balloon with an operator for each one; thus a continuous series of negatives could be obtained, and one would have precious topographical documents of incomparable precision for mapmaking. It would not be impossible to work with special panoramic cameras, the results of which would offer still more interest." This is an exact prediction of techniques that were to become common when man could predict the direction of his flight over the earth. But so long as the camera platform was a free balloon, at the mercy of the winds, there was no way to predict what terrain would lie beneath the lens; thus photographing specific "pin points" at relatively low altitudes was hardly possible. This objection, of course, becomes negligible when vast areas of the earth are to be recorded. Until the space age, the most distant views of the world were all made from free balloons. On his first ascent into the stratosphere in 1931, Auguste Picard tried to photograph, but failed because the light at the altitude of 10 miles was so intensely blue that he overexposed his film. On his second flight he put a red filter on his Leica camera, and obtained excellent photographs 10½ miles above the valley of the Rhine. The first photograph to show the curvature of the earth was made in the balloon *Explorer II* by Captain A. W. Stevens in 1935 at a height of 13.7 miles.

# 8  KITES, ROCKETS AND PIGEONS

Towards the end of the 19th century, great improvements were being made in the design of kites, particularly in the curvature of the surface, or airfoil, which gave them greater lifting power. Kites were no longer toys, and the research in perfecting them led logically, and rapidly, to the invention of the airplane. Indeed, men were airborne time and again by kites, to altitudes of a thousand feet or more. Samuel Franklin Cody, the "cowboy flyer" who toured England with Wild West vaudeville acts along the pattern of his unrelated namesake, William Frederick Cody ("Buffalo Bill"), flew a man to 1,600 feet with tandem kites. In 1903, he demonstrated his "Cody Aeroplane," as he called his team of manlifting kites, to the Royal Navy for possible use in reconnaissance. At the demonstration his son took snapshots with a handheld camera from 800 feet above the sea. We have found no record of other kite borne cameramen, but photographs from unmanned kites were taken in great number before the airplane became the standard air camera platform.

The pioneer in this branch of aerial photography was a Frenchman, Arthur Batut. He said he was first inspired to get his camera airborne on reading Tissandier's book on balloon photography, *La Photographie en ballon*. But the expense of renting a balloon, an aeronaut and a ground crew was far beyond his means. So in 1889 he built a kite, based on plans published in the magazine *La Nature*, but modified for carrying a camera.

It was of the traditional diamond shape, 8 feet 3 inches high and 5 feet 9 inches across. The upright spar consisted of two sticks, bound at each end and spread open in the middle; between them he fitted a panel of light wood on which he fastened a homemade box camera, containing a single sheet of film. Batut built a guillotine shutter, driven by a rubber band, to give an exposure speed he estimated to be from 1/100 to 1/150 sec. He described two ways to release the shutter: by a slow match fuse, set to burn for

Batut's kite camera.

the time required to fly to the desired altitude, or by an electric current carried up the kite string in twin wires. He greatly preferred the fuse, as the wires weighted down the string, and the kite could not fly to its maximum height. Furthermore, there was always the risk of breaking or some other electrical malfunction. Besides, the fuse was simpler, and Batut sought simplicity. Indeed, he compared kite photography to the invention of the dry plate: as the latter had brought photography to all, so the former would bring aerial photography to all, at little bother and expense.

Batut worked out a most ingenious technique to measure the altitude with a self-registering barometer and a way to estimate the position of the kite over the ground. He told how to measure the earth's surface from vertical air photographs and even suggested that pairs of oblique photographs taken from twin kites could be used for mapmaking by the system invented by Aimé Laussedat for

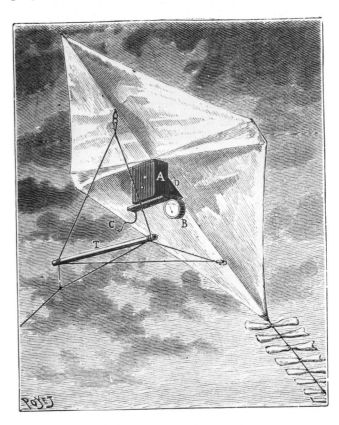

Waves on the beach at Olonne, France.
Kite photograph by Emile Wenz.

ground use. This pioneer photogrammetrist showed in 1851 that a detailed map or ground plan of terrain or buildings could be obtained from two photographs by reversing the rules of perspective, if the exact distance between the camera positions was known. Batut reasoned that the distance between identical kites flying at the same altitude from two separate ground points would be the same as the distance between their moorings. In his book, *La Photographie aérienne par cerf-volant* (1890) he outlined the uses of kite photography for the explorer (to view the land beyond), the archaeologist (to locate ruins), the military (to reconnoiter), the agronomist (to spot the progress of phylloxera, the dreaded vine disease). And he pointed out that with a kite-

borne stereo camera "everyone would be able to have the illusion of a perilous ascent, without running any risk. Because of their sensation of relief, these photographs have the great advantage of making it possible to distinguish the smallest details, which would be completely invisible in a simple photograph."

Inspired by Batut, Emile Wenz was able to place cameras for 5⅛ by 7⅛ inch plates in the air with a kite and made superb photographs of the French seacoast.

To raise the camera to a greater height, Batut flew three kites in tandem. William A. Eddy, who claimed he was the first in America to take photographs from kites in 1895, regularly used even more: "I have as yet taken no kite photographs with a single kite. It requires from six to nine kites seven and nine feet in diameter and a pull of from thirty to sixty pounds to lift the camera and frame to a height of 1,000 feet." Like Batut, at first he released the shutter with a burning timed slow match. Later he found that a light-weight string attached to the shutter release gave him not only the means to make exposure, but to steady the camera. "After each picture, which is taken by pulling the very thin camera string, the camera and kites, still flying, are pulled down to the earth, but the camera is braced into the main cable so far below the kites that when the camera is at the earth and being set for another picture, enough line is still out to enable the kites still to fly without danger from sluggish earth currents. I have in this way made as many as thirty-two exposures in one day." Eddy's chief problem was handling his team of kites. He flew them mostly from the roofs of buildings; occasionally the line would break and, suddenly released from a fifty-pound pull, Eddy would be sent sprawling on the roof. Where there was no parapet, he rigged up a lifetime at a safe distance from the edge of the roof. He wrote: "While I was photographing from mid-air the great Sound Money Parade of October 31,

1896, with a camera suspended above Broadway, New York, the main kite cable was broken in a peculiar way. Three kites built for light winds were at a great height when they were borne down by a gust, the main kite-line becoming entangled in the high iron framework of an unfinished structure on the east side of Broadway, the kites having been sent up from the roof at the corner of Broadway and Duane street. The main cable was snapped by an attempt to drag in the entangled line, the three kites and one flag disappearing to the eastward. They were never recovered. Meantime, the camera fell with a swinging motion to the top of the next building, far below the level of the fourteen-story building from which I had sent out the line of kites. I was obliged to crawl across the wire netting in an interior court before I recovered the camera and replaced it in the line. I then continued my mid-air photographing until nearly 5 P.M."

Eddy's airview of the Sound Money Parade is the earliest use of the airborne camera for news photography that we have found. His accomplishment was soon eclipsed by an amazing series of panoramas of San Francisco in ruins, taken six weeks after the fire and earthquake of 1906 by George R. Lawrence with a mammoth camera airborne by seventeen kites.

Lawrence's first aerial photographs were taken in 1901 from a balloon over the Chicago Stockyards. A specialist in the production of extremely large pictures (he photographed the entire Alton Limited train of six cars and a locomotive on one 4 by 8½ foot negative for the Chicago & Alton Railroad), he built what he called "lightweight" panorama cameras for films ranging in size from 10 by 24 inches to 30 by 84 inches. During the ascension over the stockyards the netting around the balloon's envelope, from which the car was suspended, broke apart. Lawrence fell to the earth, 228 feet below; only by chance was his fall some-

what broken by telegraph wires; miraculously he was not hurt. Undaunted, he accepted an assignment from the *Minneapolis Tribune* to take balloon views of Minnesota towns. A second narrow escape over a lake convinced him that a balloon was not the ideal camera platform.

So he began to build kites, "Captive Airships" he called them, of different sizes for various wind velocities, and suspended lightweight panorama cameras from the main kiteline by outriggers. Exposures were made by electric current carried through the insulated core of the steel cable kiteline; the moment the shutter snapped, a small parachute was released. At this signal that the picture was taken, the kites were pulled down and the camera reloaded.

When the news of the San Francisco earthquake and fire in 1906 reached Lawrence in Chicago, he rushed to the stricken city with his battery of kites. He sent all seventeen of them flying from a ship in San Francisco Bay with a panorama camera dangling beneath them. It was raining, and the cable became wet; the shutter would not obey his command; and for a while it seemed that his bold project was doomed to failure. But the sun suddenly came out, dried the cable, and from an altitude of 2,000 feet the camera recorded a panorama of the entire extent of the ruined city. Bleak, desolate, and more detailed pictures were taken from lower altitudes with land-based kites. The largest of Lawrence's air photographs of the destroyed city measure 48 by 18¾ inches. They are contact prints made directly from the mammoth negatives — the largest yet taken from any airborne vehicle.

While Lawrence was flying his kite camera, and the Wright brothers were perfecting their airplane, the German army was experimenting with rocket photography. The idea of shooting a camera into the air was not, even then, new: in 1888 the magazine *La Nature* described the photo rocket, *photo-fusée*, of Amédée Denisse. The editor re-

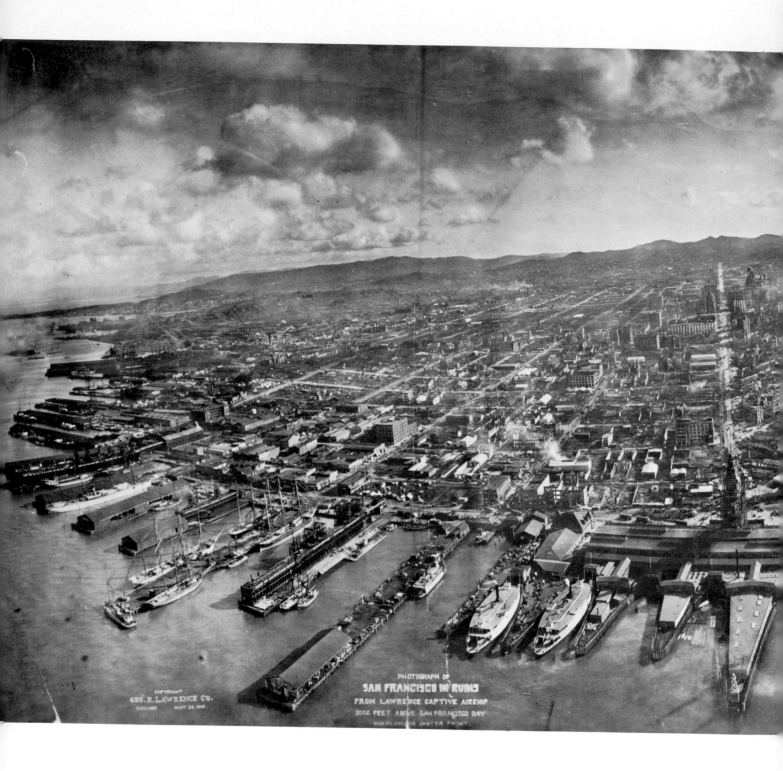

PHOTOGRAPH OF
**SAN FRANCISCO IN RUINS**
FROM LAWRENCE CAPTIVE AIRSHIP
2000 FEET ABOVE SAN FRANCISCO BAY
OVERLOOKING WATER FRONT.

COPYRIGHT
GEO. R. LAWRENCE CO.
CHICAGO    MAY 28, 1906.

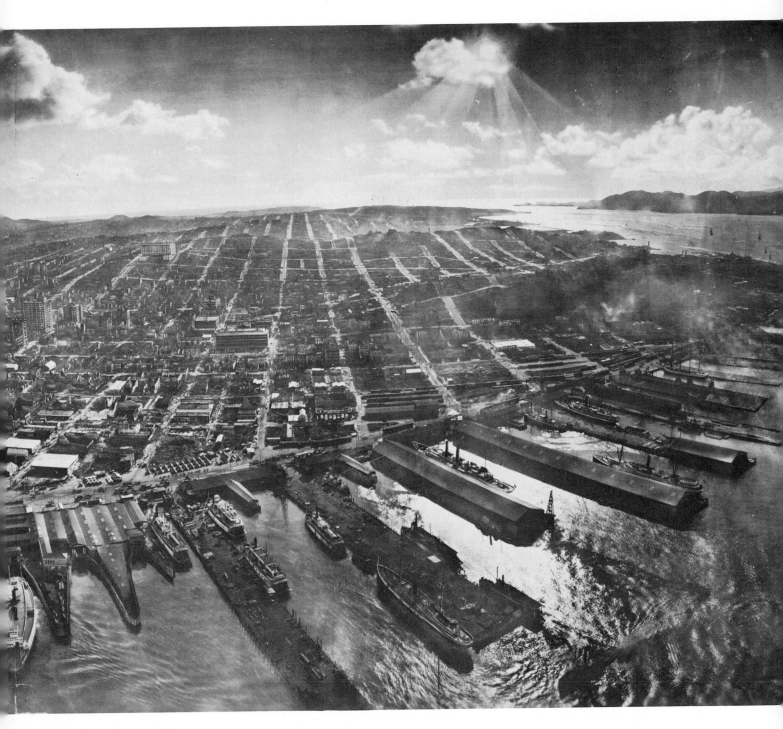

"San Francisco in Ruins." 1906.
Kite photograph by George R. Lawrence.

ported that he already had some promising results and "as soon as the new device will work consistently, we will describe it more completely." But nothing further appeared.

Three years later, in 1891, a patent was issued in Germany to Ludwig Rahrmann for a photographic system that was airborne by either a gun of large caliber or a rocket. A camera and a parachute were fitted within a projectile. The specification reads: "The projectile is fired high in the air in the direction of the object to be photographed, a charge of explosive being then ignited and the parachute apparatus being thereby set free from the projectile. The parachute then opens automatically, falling by itself, the photographic apparatus hanging perpendicularly below it, and by a suitable arrangement taking one or more instantaneous photographs of the positions on the earth below, the parachute being then brought back to the point from which it was projected by a line, one end of which is attached to it, the other being retained at the starting point."

In 1903 yet another patent was issued for a rocket camera, to Alfred Maul. His system was described in *The Illustrated London News*, December 7, 1912, with reproductions of excellent photographs taken by it. The camera, for 7⅜ by 9⅞-inch glass plates, was carried by a rocket 19 feet 9 inches tall, powered by gunpowder. Eight seconds after launching, by which time the rocket reached an altitude of about 2,600 feet, the nose cone blew off and the camera, fastened to a parachute, was ejected. The exposure was made by a timing device. Complete field equipment was provided, manned by a well-drilled squad of soldiers. The launching tower, on wheels, was easily moved about, and processing facilities were in a second wheeled vehicle. Willy Ley, in his *Rockets, Missiles, and Space Travel* writes about Maul's pioneer work with the admiration of a fellow rocketeer: "One interesting and useful trick was the insertion of a 30-foot line between camera and guiding stick. The heavy guiding stick with the empty rocket cases struck the ground first on descent, so that the camera was still 30 feet above ground and was lowered over this remaining distance by a parachute which did not have anything else to carry."

German Army photo rocket squad with Alfred Maul's equipment, 1912.

German countryside from a photo rocket, 1912.

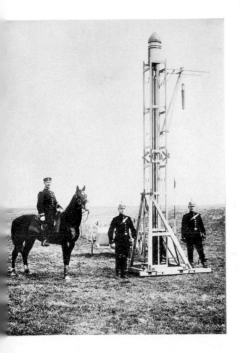

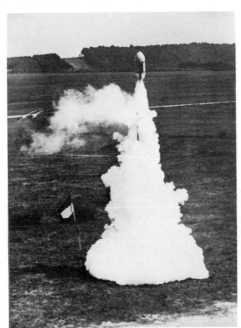

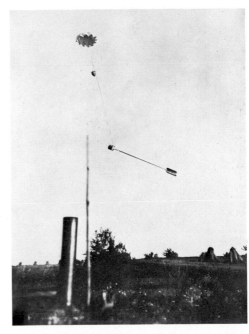

47

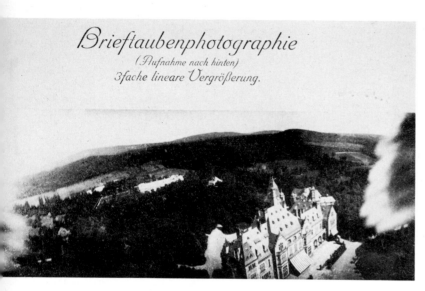

*Brieftaubenphotographie*
*(Aufnahme nach hinten)*
*3fache lineare Vergrößerung.*

Pigeons with cameras and a photograph taken by one of them, about 1908.

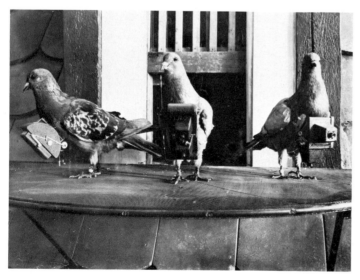

Maul's rocket photographs were the center of attraction at the 1909 International Photographic Exhibition in Dresden. Another air photography system was also demonstrated there. Pigeons, with automatic miniature cameras harnessed to their bodies, flew over the exhibition hall, photographing. The exposed film was quick processed and postcard enlargements sold to the visitors.

The pigeon camera had been patented in Germany in 1903 by Julius Neubronner. His father, a pharmacist and pigeon fancier, combined his profession and avocation by inaugurating a carrier-pigeon delivery service between his pharmacy in Cronberg, a village 22 miles northwest of Frankfurt am Main, and a hospital in the mountains that was difficult to reach by road. The small camera, which weighed only 2½ ounces, took negatives 1½ ins. square; exposures were made automatically at half-minute intervals by a timing mechanism. *The Scientific American* noted: "As a carrier pigeon, after starting, at first describes a spiral line, it is quite easy to take a number of views of a given portion of the ground from different points of view. After once determining the position of its cote (which it recognizes from a distance upward of 20 miles) the pigeon flies towards its goal in a straight line and at the uniform speed of an express train, so that the route to be recorded photographically can be readily determined in advance."

In 1912 Neubronner built a miniature panorama camera for his pigeon photographers, with a swinging lens covering 1¾₁₆ by 3-inch film.

The magazine *L'Illustration* wrote in 1908: "It is quite natural to see birds becoming photographers at the moment when men are beginning to become birds." Already photographs were being taken from airplanes which soon were to supplant completely balloons, kites, and pigeons as camera vehicles. Of the pioneer air photography systems, only the rocket was to survive.

# 9  PHOTOGRAPHING FROM AIRPLANES

The advantage of the airplane as a camera platform over balloons, kites, rockets and pigeons is that it can be flown with great accuracy at specific heights over any area of the world; its flight is relatively steady and its speed constant and swift. With an automatic camera, overlapping photographs can be taken in quick succession, so that in a few minutes vast areas of the ground can be recorded. The photographs can be pasted together in a "mosaic" that can be scaled and read like a map. Any two adjacent overlapping air photographs are stereoscopic pairs, and can be viewed in three dimensions in a stereoscope; from them the heights of buildings and mountains and the depth of valleys can be measured with an accuracy practically equal to land-based surveys, and contour maps can be drawn almost automatically of any terrain, whether it be dense jungles where no man has set foot, or inaccessible mountain peaks. Even the depths of river bottoms beneath fathoms of clear water can be measured.

Although the Wright brothers showed the world how to fly a heavier-than-air craft in 1903, it was more than a decade before the airplane became a practical camera platform. It was impossible for the pilot to operate a camera while flying one of the first Wright planes, for he flew it with his body. He lay prone on the lower wing, his hips in a cradle and his arms outstretched. To turn, he swung his body from side to side; this action moved the rudder and warped the wings. To climb or descend, he moved with his left hand the lever that controlled the elevator. He hung on with his feet and his right hand. In 1907 the Wrights built an improved airplane; the pilot now sat upright on the edge of the lower wing and a passenger could sit beside him.

L. P. Bonvillain, a Pathé cameraman, was a passenger on one of Wilbur Wright's demonstration flights at the Camp d'Auvours, near Le Mans, France in 1908. We have yet to locate the motion picture film he shot, but an enlargement of one of the frames was published in the magazine

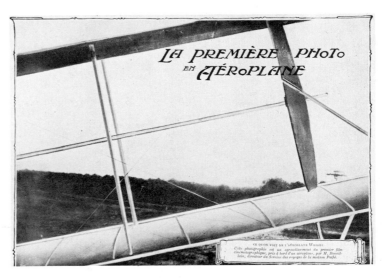

"The First Photograph from an Aeroplane" was a motion picture filmed by Pathé cameraman L. P. Bonvillain from Wilbur Wright's airplane near Le Mans, France. Only this reproduction, from the Christmas, 1908, issue of the magazine *La Vie au Grand Air*, survives.

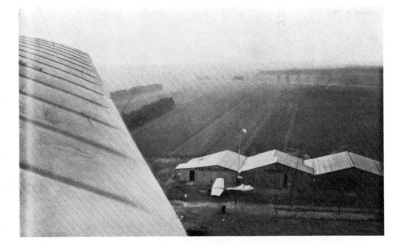

The Camp de Châlons airfield, near Reims, France, photographed from an Antoinette airplane for the magazine *L'Illustration*, 1909.

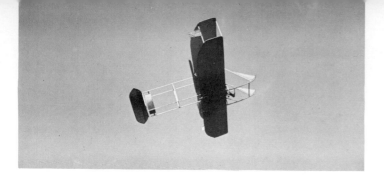

A Wright Model B airplane.

*La Vie au Grand Air,* captioned "The First Photograph from an Aeroplane." It is not so much from an airplane as of an airplane in flight, for the picture is dominated by the pair of wings, cutting diagonally across the frame.

Four photographs taken by a cameraman named Meurisse for the Beranger picture agency from the graceful Antoinette monoplane of Hubert Latham were published in the Christmas, 1909 issue of the magazine *L'Illustration.* They show the factories, assembly plants and repair hangars of "Aviation City," as the hastily erected flying field at the Camp de Châlons, near Reims, was named. In one of the photographs, behind the blur of the propellor, a Farman biplane appears in flight; in another an Antoinette monoplane sits by its hangar. In each photograph a wing of Latham's plane appears, as if to prove that the photographs were indeed taken from an airplane and not from a balloon.

Latham himself was a photographer. He took a camera with him on his unsuccessful attempt on July 19, 1909 to cross the English Channel. Unlike the Wright planes which were built purposely unstable so that the pilot had to have his hands on the controls for every second, the Antoinette could be flown "hands off" for quite long intervals. Latham, writing about the flight for *The Daily Mail,* said that shortly after takeoff "I ran up to a masthead . . . a flag that I had decided should only be hoisted at the moment of leaving land." He estimated that his altitude was 1,000 feet — unusual for the time — and from this height he looked down at the destroyer *Harpon* which the French navy had supplied as an escort.

"Then I took in my hands a little camera I had taken up with me," Latham wrote. "The cliffs had slipped away behind me; below and in front, in the distance lay the torpedo-boat destroyer. Smoke was pouring from her two short funnels, there was a foaming wake astern of her. I could see that she was being hard-pressed. 'What a beautiful snapshot that would make,' I said to myself and was preparing to take a picture when a disconcerting sound came to my ears. My motor was showing signs of breaking down. I could hear that more than one of the eight cylinders was misfiring. Instantly I gave up any idea of photography and did everything I could to remedy the defect. . . . But it was all in vain. In a few seconds my engine had stopped entirely. It was maddening, but I was helpless. Never before had the engine played me such a trick, after so short a flight.

"The machine was under perfect control during the descent. Instead of diving into the sea at an angle, I skimmed down so that I was able to make contact with the sea with the aeroplane practically in a horizontal position. It settled on the water and floated like a cork. I swung my feet up onto a cross-bar to avoid getting them wet. Then I took out my cigarette case, lit a cigarette, and waited for the *Harpon* to come up."

We do not know if "the soaring snapshotter," as *The Amateur Photographer* called him, made any photographs in later flights.

The first photographs taken in England from an airplane were made by Charles F. Shaw, photographer for the *Nottingham Guardian,* on a flight in a Farman biplane in 1910. He wrote of his experience: "There is the wonderful exhilaration of rushing through the air at a terrific speed with the wind whipping the tears like rain-drops down your cheeks. But there is something more — an exultant delight in soaring through space and looking down upon real towns, rivers, and far-reaching landscapes spread out like some huge coloured map. . . . Combining flight and photography is attempting almost too much to be pleasant as a regular pursuit. One must experience to realise the difficulty of holding a camera and changing plates whilst tearing through the air at an altitude of 400 feet. More than once the picture machine was all but blown away, and it was rather more than inconvenient to place the lens between the network of wires and bamboo poles in order to view the scene one wished to reproduce."

While flying with Phil O. Parmalee in a Wright Model B airplane over South San Francisco in 1911, Lieutenant G. E. Kelly, U. S. Army, photographed over his feet with a borrowed Kodak roll film camera.

The armies of the world were slow to recognize the striking power of the airplane. Never, the military thought, could airplanes carry bombs of sufficient size and in sufficient number to be of any effect, nor could personnel in any significant number be carried by them. However, the reconnaissance potentials were foreseen, and in 1911 practical trials were carried out in San Francisco by Lieutenant G. E. Kelly of the United States Army in a Wright Model B biplane piloted by Phil O. Parmalee, an exhibition flyer for the Wright company. With a borrowed Kodak roll-film camera Kelly shot over his feet at what could well have been military objectives: a stretch of railroad track, the flying field with parked aircraft, the Presidio military establishment, and South San Francisco. A newspaper man reported: "Parmalee declared that with an aeroplane armored according to ideas which he described, he would take a photographer directly over the lines of a hostile force, and would face the combined artillery and rifle fire of a regiment or an army corps without the slightest fear, flying a mile above earth, from which distance it would be easily possible, with proper equipment, to make photos which would betray every detail of the enemy's strength and equipment."

Airplanes were now flying higher: in 1910 a Wright Model B reached 11,567 feet. They were used by the French army in the Moroccan crisis of 1911 to carry cameras, and a photographic service was formed. In 1913 Captain Cesaro Tardivo of the Italian army showed the members of the International Congress für Photogrammetrie a mosaic of Bengasi, Libya; he reported that the mapping camera had been carried over the city by an airplane.

A year later the antiaircraft guns of World War I were desperately trying to bring down hostile camera-carrying aircraft. Photography had become vital to victory.

# 10   THE EYES OF THE ARMY

In the first weeks of hostilities in 1914 a camera was found in the wreckage of a Zeppelin captured at Badonvilliers. This led the French to hastily reactivate the photographic section of the air service, which had been deactivated at the close of the Moroccan crisis. Louis Philippe Clerc, who had left the University of Paris, where he was professor of photographic science, to join the army as a noncommissioned officer, was assigned to it. "I had to second a very young officer totally unacquainted with photography," he recollected, "and to devise in the field, without any means of scientific experimentation, a photographic technique adapted to this very special branch of photography."

Besides setting up technological requirements, Clerc wrote the first instruction manuals for the interpretation of aerial photographs. He devised ingenious techniques for extracting the maximum information from them. He showed that if the month, day and hour of photography is known, cast shadows will reveal the direction of North and indicate the heights of terrain features.

Although the British had experimented with aerial photography, the Royal Flying Corps had no air cameras, no materials, and no processing facilities. Flyers, convinced that photographs of what they saw as they flew over enemy lines were more valuable than written reports began to take

Battlefield, with Allied airplane in flight.

amateur cameras with them them on observation sorties. Lieutenant J. T. C. Moore-Brabazon (later Lord Brabazon of Tara) and Lieutenant C. D. M. Campbell were among the first to take snapshots on their own initiative; from them they made sketch maps which they showed to General Headquarters. An unexpected reaction greeted this effort: photography, their superior offices told them, "was a most disgraceful thing to have attempted" and it was made clear to them that "trench maps were not within the sphere of the Royal Flying Corps." But within months the value of air photographs became obvious and the attitude of the high command altered. Better photographs were now desperately needed, and to take them special cameras were required.

Lieutenants Moore-Brabazon and Campbell were ordered to England to get a prototype designed and built as quickly as possible. On their arrival they gave their specifications to the Thornton-Pickard Manufacturing Company, Ltd., a firm which specialized in making superbly crafted photographic apparatus. Eight days later they were back in France with the first Model "A" air camera, a brass-bound tapering wooden box for 4 x 5-inch plates, with a focal shutter and a 9⅞ inch Zeiss Tessar lens. The plates, enclosed in ingenious lighttight paper envelopes, were inserted into the camera one after the other by hand.

The first improvement was to add a magazine. A dozen fresh plates were stacked face down in a box directly over the focal plane. After exposure the plate was slid in a frame over the second box, into which it fell. The mechanism depended entirely upon gravity, and plates could be changed only when the camera was held vertically. Throughout the war this "C" type camera and the "E" model, of similar design but made of metal instead of wood, were standard with the Royal Flying Corps.

It was not only awkward for observers to hold these cameras over the side of the plane in the slip stream, but it was difficult to point them directly down. And it was danger-

ous, for if an enemy plane attacked, the observer could not man his machine gun until he had stowed away his camera. So the "C" and "E" cameras were attached to the side of the plane. This was a poor position, but there was no alternative until larger planes were built with fuselages wide enough to install the camera in the cockpit over a hole in the floor.

With the "C" camera, exposures could be made in rapid succession — quickly enough so that the photographs would overlap each other, and provide the photo interpreters with stereo pairs. This was essential, for the most important and vital military information is often to be found in the most minute details of the photographs, and the third dimension given by stereoscopic vision may be the only clue for the correct recognition of what the camera recorded.

Unlike those stereoscopic views, once so popular, which give a convincing, "realistic" illusion of depth, pairs of overlapping aerial photographs give an exaggerated, highly distorted sense of height. Hummocks become hills, gulches seem to be deep chasms, and ordinary houses, skyscrapers. This exaggeration helps the interpreter: a machine gun emplacement seems to rise up from the ground; he can look under the bridge as well as on it; he can count long trains of freight cars and see the crumbling walls of bombed targets.

Normal stereoscopic photography is based on the phenomenon that each of our two eyes sees the world from a slightly different viewpoint, determined by the interpupillary distance, approximately 2½ inches. By constructing a camera with two lenses 2½ inches apart, records can be obtained corresponding to the image formed by the left eye and by the right eye. With a simple optical instrument called a "stereoscope", each picture can be viewed simultaneously and independently by each eye; the brain responds to the stimuli of these two images exactly as in observing the scene photographed. But if the two pictures are taken at a distance greater than 2½ inches, the effect of depth is increased, a phenomenon known as "hyperstereoscopy".

Model "A" air camera, built for the British Royal Flying Corps by the Thornton-Pickard Manufacturing Company, Ltd., 1914.

World War I reconnaissance photographs were typically taken from planes flying 60 m.p.h. at an altitude of 10,000 feet. With an 8-inch lens on a 4x5-inch plate, each photograph covered 6,2500x5,000 feet of terrain. Exposures were made at intervals of 14.5 seconds. During this period the plane traveled 1,250 feet. Thus photograph B overlaps photograph A and so on for the entire series. The overlapping portions of the photographs can be viewed in exaggerated third dimension with a stereoscope. Plane must fly straight and level at constant speed despite enemy action to secure a useful run of photographs.

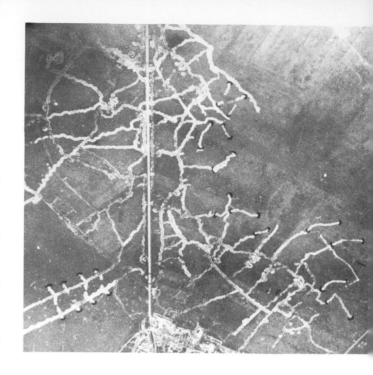

Development of a trench system preparatory to an offensive during World War I. The second photograph was taken 3 days after the first, and the third 11 days later. Note the construction of "jump off" trenches at the right of the highway.

World War I was characterized by trench systems, and successive photographs showing their growth enabled commanders to anticipate attacks. Although guns could be concealed, it was almost impossible to hide tracks leading to them from ammunition dumps. By close study of stereo photographs, interpreters could not only detect the tracks and the gun emplacements, but could identify the type and caliber of the guns themselves — even though the images occupied but a few millimeters on the photograph.

America was totally unprepared for photo reconnaissance when she joined England and France in the great conflict. A School of Aerial Photography was established by the army at the Eastman Kodak Company in Rochester and at Cornell University, where students were taught how to fly reconnaissance planes, take photographs, process them and interpret them. Overseas, a Photographic Section of the American Expeditionary Forces was activated with Lieutenant (later Colonel) Edward Steichen in command. After the war he wrote:

"The consensus of expert opinion, as expressed at the various inter-Allied conferences on aerial photography, is that at least two-thirds of all military information is either obtained or verified by aerial photography.... The success with which aerial photographs can be exploited is measured by the natural and trained ability of those concerned with their study and interpretation. The aerial photograph is itself harmless and valueless. It enters into the category of 'instruments of war' when it has disclosed the information written on the surface of the print.

"Photographic reconnaissance is a most difficult and ungrateful part of aerial observation. It gets more recognition from the enemy than any one else." Steichen related how a group of enemy fighter planes attacked an A. E. F. reconnaissance plane over the Hindenburg line: "The observer, deliberately disregarding danger, kept on operating his camera.... The pilot, though slightly wounded, was able to get his riddled ship back home.

"When the plane landed the observer was found dead, his body fallen forward against the camera. A bullet had gone clean through his heart, but orders had been complied with. The magazine containing the plates was intact, and when developed . . . produced one of the finest sets of photographs made in the A. E. F."

With an automatic camera, which changed the plates and released the shutter by power at predetermined times by an intervalometer, the observer could both fight and photograph. But such cameras, although designed, patented and built during the war, were not, according to Steichen, in use by the Allies at the Western Front until the last month of the war, when fifteen were put in operation over the lines. These cameras held fifty plates in an ingenious revolving magazine powered by an outboard propeller connected to the camera mechanism with a flexible shaft. Steichen wrote that "On one occasion two planes were sent out on a photographic mission; one was equipped with a DeRam auto-

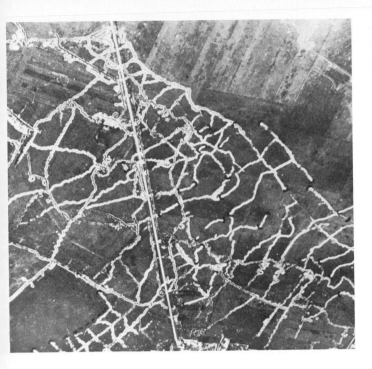

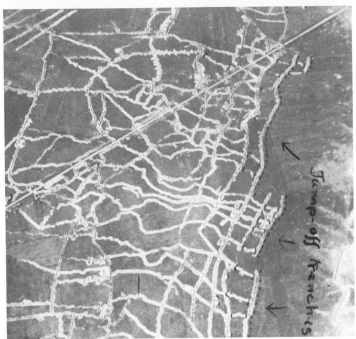

matic and the other with a hand-operated camera. During the mission these two planes were attacked by seven enemy ships; two of the enemy machines were brought down, the remaining five quit. The observers in each plane naturally made good use of their machine guns, but the plane with the automatic camera also continued ticking off pictures throughout the flight and they brought back a perfect reconnaissance without a single gap in the series."

In 1919 a Member of the British Parliament, Spencer Leigh Hughes, paid tribute to the part played in the war by the air camera. "We have beaten the Germans in nearly every invention or development of engines of war," he said. "But it is in the realm of aviation photography that our supremacy has been most conspicuous."

When he made this proud boast, the M. P. was unaware that as early as May, 1915, the Germans had much better equipment in operation over the Western Front. Oskar Messter, a motion-picture pioneer, designed a semi-automatic roll film camera that is the prototype of all modern aerial cameras. It took 250 negatives, each 4 inches square,

on 100 feet of film 4¾ inches wide. By a single manual operation the shutter was cocked and fresh film brought into position; the shutter was released by a trigger. Messter later designed a fully automatic camera, powered by a propellor, for 2⅜ by 1½-inch negatives. This camera, designated "Rb" (for *Reihenbilder*, series-pictures) was primarily intended for mapping; at an altitude of 8,200 feet — then reasonably above the range of anti-aircraft fire — an area 3.1 by 37.3 miles could be covered by the overlapping 250 pictures.

When peace was declared, the record was studied. The British reported that they had taken 6,500,000 photographs in the last year of combat; 1,300,000 more were taken in five months by American airplanes. Cameras, airplanes, processing equipment, and the specialized skill of photo interpretation was brought to a new height. Photo reconnaissance was established.

But staggering as this record seemed, it paled to insignificance a score of years later, when war again became global.

# 11  PHOTO RECONNAISSANCE IN WORLD WAR II

Two propaganda films, one German, one British, show the importance that both belligerents placed on photography. *Baptism by Fire*, the Nazi documentary of the terror bombing of Poland which, it is said, Hitler showed to the rulers of satellite countries as a warning of the consequences of non-cooperation, opens with photo interpreters at work, planning the attack. *Target for Tonight*, showing how the Royal Air Force mounted a bombing raid on Germany, contains a sequence showing photo interpreters assessing the effect of the raid from aerial photographs.

Even before hostilities opened, British Air Intelligence already had extensive photo coverage of Germany and much of western Europe, taken secretly by a daring civilian, Frederick Sidney Cotton, a veteran of the Royal Naval Flying Corps of World War I who had established an air-mail service in Newfoundland, had done some air survey work there, and then had set up a color photography business in London. His work required frequent trips to Germany, and the logical way for him to travel was by private plane.

Air Intelligence saw in this activity an opportunity to get photo coverage of Germany. Constance Babington-Smith, in her book *Evidence in Camera* (retitled *Air Spy* for the American market), tells how Cotton was supplied with an elegant twin-engine Lockheed 12A airplane. Below the passenger cabin, concealed by a sliding panel, were three aerial cameras. At the touch of a button the panel slid noiselessly away, uncovering the cameras, which took photographs automatically every few seconds. Cotton and his co-pilot Robert Niven flew this secret photo plane at 20,000 feet over Europe and, in the spring of 1939, with extra fuel tanks to increase their range, they made overflights of Malta, Libya and Eritrea. The sky-blue plane, handsome on land, inconspicuous at high altitudes, was well known in German airfields. Once, at an air rally at Frankfurt am Main, a Nazi General, chief of the Tempelhof

airfield near Berlin, expressed a desire to go up. "Cotton was delighted to oblige," Miss Babington-Smith writes. "On a sudden impulse he recalled that a favorite aunt of his had always raved about the beauty of the Rhine at Mannheim. He would love to fly the General over this beautiful region if it could be permitted. In fact, there was quite a bit of competition for joyrides in the Lockheed. Accompanied by a series of Luftwaffe generals and colonels, Cotton flew hither and thither at a couple of thousand feet, over airfields and ammunition dumps, the factories and fortifications. And while his passengers commented with interest on the Lockheed's performance, Sidney casually flicked a little switch, and down below the cameras went clicking away."

In August all civilian flying in Germany was prohibited, and Cotton was grounded in Berlin. Somehow, just days before Hitler invaded Poland, he wrangled permission to fly out via the Dutch border — with all three cameras clicking away.

At the outbreak of hostilities the Royal Air Force at first assigned the task of taking aerial photographs to Bomber Command, which sent Blenheims, in which cameras had been installed, over the lines. The results were disappointing: the clumsy craft were easily brought down by anti-aircraft fire when flying at moderate altitudes; at high altitudes the cameras in them froze and became inoperable. Cotton was consulted. He and his colleagues Niven and Maurice Longbottom made their recommendations in the form of a memo, which, as Miss Babington-Smith comments, was remarkably prophetic:

The best method appears to be the use of a single small machine, relying on its speed, climb and ceiling to avoid destruction. A machine such as a single-seater fighter could fly high enough to be well above Ack-Ack fire and could rely upon sheer speed and height to get away from the enemy fighters. It would have no use for arm-

ament or radio and these could be removed to provide room for extra fuel, in order to get the necessary range. It would be a very small machine painted so as to reduce its visibility against the sky.

The proposal was at first rejected, but the Air Ministry was finally persuaded. By December, Spitfires — the fastest planes of the R.A.F. — were flying solo over enemy territory, bringing back photographs in unprecedented number. Later Mosquitoes, capable of greater range, were also used. Each plane was fitted with three cameras, and in each camera was enough film for 250 negatives, each measuring 8¼ x 7 inches. In 1943, with the introduction of the F.52 camera, the capacity was increased to 500 negatives.

The P.R.U. (for Photo Reconnaissance Unit) planes carried no guns. They were unarmed not only to decrease their weight and thus to increase their speed and range, as Cotton suggested, but also to remove the pilot's temptation to engage in combat at the expense of securing photographs. His only defense was speed, and his orders were to run away from planes attempting to intercept him.

In the European theater of war the American Army Air Force used F-5 airplanes — modified P-38 or Lightning fighters. Up to the last months of the European war this plane with its twin engines was ideal; its central cockpit enabled cameras to be fitted in its nose, in front of the propellors; its two engines doubled the pilot's chance of returning; its speed enabled him to outrun enemy planes. But when the Germans started to fly their much faster jet aircraft the Spitfires, the Mosquitoes and the F-5s were doomed. For security each photo plane was escorted by fighters; photo coverage was no longer secret.

Few flyers in World War II were more courageous than photo pilots; they had no defense against attack, yet were ordered to fly in the enemy's fire. The most illustrious of these courageous men, whose essential role in the winning

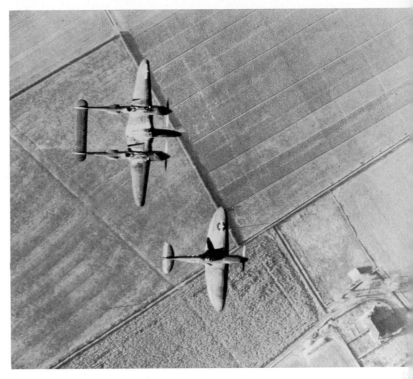

Photo reconnaissance airplanes of World War II: U. S. Army Air Force F-5 (twin engines) and Royal Air Force Spitfire.

Typical bomb damage assessment photograph recording attack upon the Dortmund-Ems Canal, Germany. Royal Air Force.

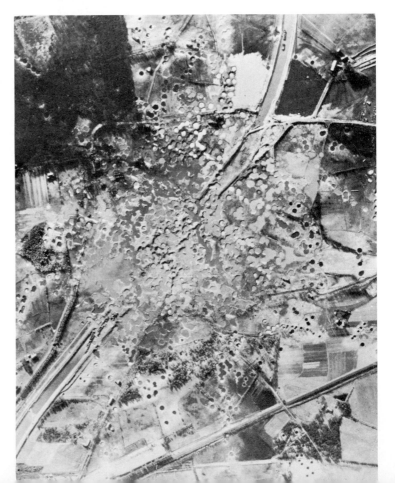

Royal Air Force bomber over Hamburg, Germany, 1943.
From a bomber above the Lancaster shown in this photograph a flash bomb was dropped and the camera lens opened. A few seconds later, at a safe distance beneath the airplane, the bomb exploded with a brilliance of such intensity that features of the ground are visible, and of such brevity that the propellors of the bomber are stopped. Tracer bullets are recorded as bright lines which follow the pattern of the camera-carrying plane's evasive action.

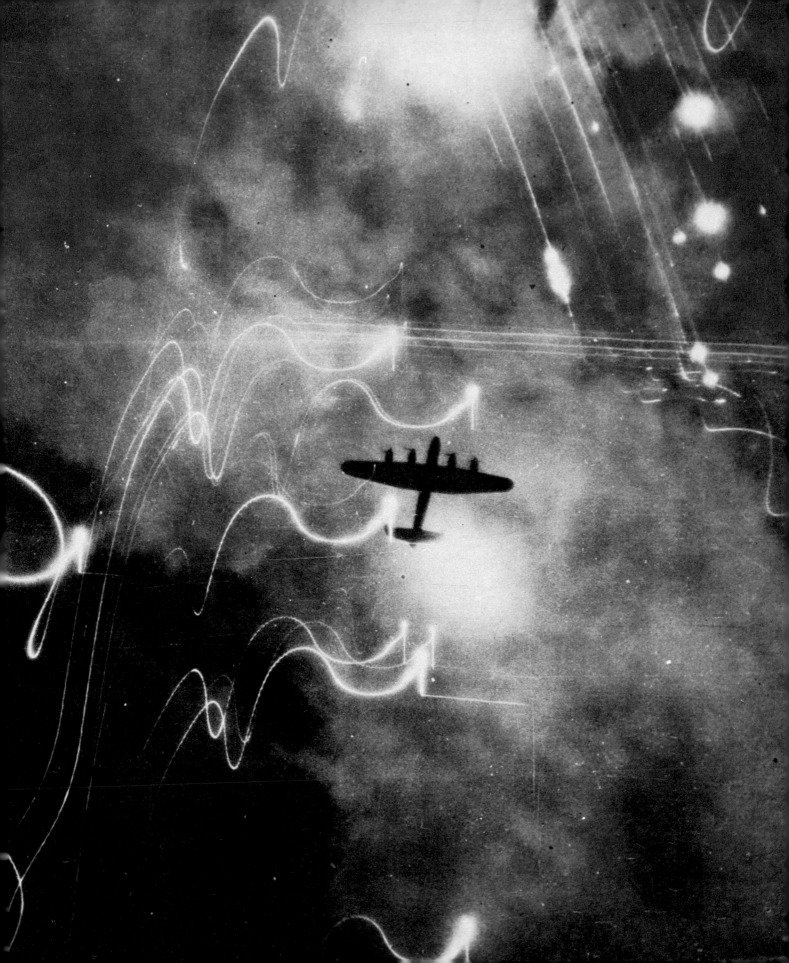

of the war has yet to be chronicled in depth, was the writer-flyer, Antoine de Saint-Exupéry, author of the best-selling books *Night Flight* and *Wind, Sand and Stars.* He served in the Mediterranean Allied Photo Reconnaissance Wing. To those of us who were under the same command, he was, at 44, an old man; despite his 22 years experience as an aviator, he had almost to relearn flying to manage so fast a plane as the F-5. It is said that only through the intervention of Col. Elliot Roosevelt, commanding officer of the Wing, was he allowed to do so. At 8:45 on the morning of July 31, 1944 he took off from Corsica to photograph the area east of Lyons. The official interrogation report, signed at 3:30 that afternoon, states "no pictures . . . pilot did not return and is presumed lost."

When Col. Roosevelt was transferred from Italy to London, Col. Karl Polifka took his place as commanding officer of the Mediterranean Allied Photographic Reconnaissance Wing. "Polifka was thirty-three, allegedly too old for operation flying," Miss Babington-Smith recounts. "When he went on sorties he used to enter himself in the records as Lieutenant Jones. Perhaps the most famous photographs he ever took were of the valleys either side of Cassino, from the same level as the flak on the hillsides. They say that when Polifka's General saw the pictures he called for Lieutenant Jones to congratulate him, and started writing out a citation. When Polifka appeared with a sheepish grin, the General and he both thoroughly enjoyed the joke."

The enormous amount of film so hazardously obtained was processed in machines that could turn out as many as 500 prints per hour. The roll of film was run over a system of rollers at the tops and bottoms of deep tanks filled with developing and fixing solutions, washed, dried, and then wound up. In a second continuous processing machine, similar to the first, the film was printed, picture by picture, on rolls of sensitized paper that were run through the process-

ing solutions at the rate of four feet a minute, dried, and cut up into individual photographs.

In 1944, Col. Polifka commended his command for having flown 1,250 sorties and having produced 3,000,000 prints in the month of August alone. Similar statistics could be furnished for photo reconnaissance units in all the theaters of war.

Interpretation became highly specialized, and was divided into three priorities.

First Phase Interpretation was a swift, immediate examination of the photo coverage to determine if the pictures revealed evidence of the enemy's activities of such importance that Headquarters should be notified at once — such as the change in location of a capital warship, or the withdrawal of a large amount of armor from a strongpoint. Often this interpretation was done from the negatives, without waiting for the prints to be made from them.

Second Phase Interpretation was a routine, day-by-day study of airfields, harbors, railroad yards, industrial plants, and defenses. Aircraft were identified, ships were named, the contents of open freight cars described, the products of factories enumerated, the type and caliber of artillery estimated, the position of radar installations pinpointed. The effect of bombing was assessed in detail. This interpretation was done at night, so the information was available to the Air Force staff each morning.

Third Phase Interpretation was an exhaustive re-examination of the photographs by specialists in aircraft, communications, shipping, defenses, radar, and especially such industries as oil refining and aircraft production. Photographs were made of shipyards every day, weather permitting; from them the number of submarines under construction could be reported and the time of their launching estimated. It was even possible to describe new types of landing craft with such accuracy that they could be identified the very day they were put in use. A running inventory

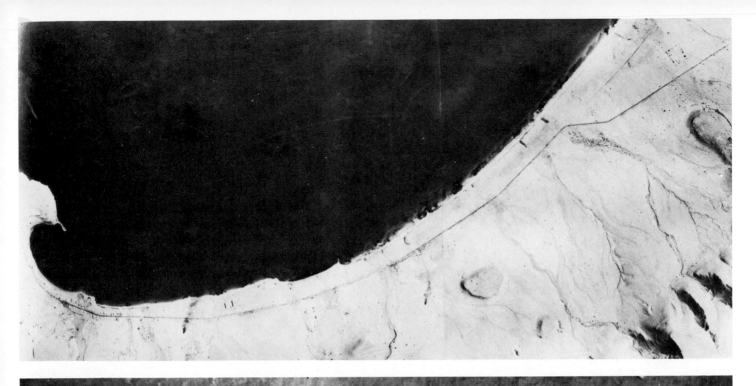

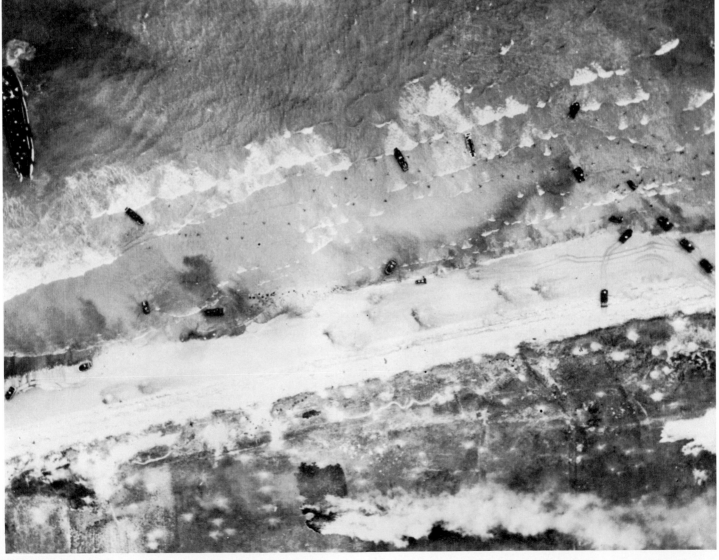

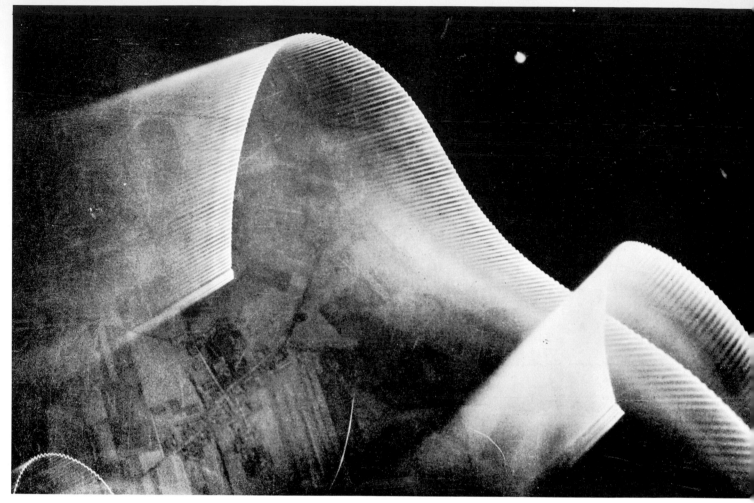

Searchlight patterns, recorded by a
Royal Air Force plane over Berlin. The
flowing light patterns were caused by
sweeping beams of searchlights recorded on
film while the camera's shutter was open
for a brief time exposure.

A Royal Air Force photo interpreter noted:
"On the photographs are the tracks of
three searchlights, A, B, and C, which
were present and active simultaneously.
The track made by a searchlight can be
divided into:

"1. The track of the searchlight bowl. The
track crosses the photograph in wide
sweeps because the aircraft was vibrating.

"2. The beam of the searchlight produces
the curtain which lies along one side of
the track of the bowl. The curtain is
alternately bright and dim because the
vibration of the aircraft makes the motion
of the searchlight beam across the field
alternately slow and fast.

"3. The fact that the beam is visible
and fades away more or less evenly shows
that there was mist or haze of consider-
able depth and uniformity. If the air had
been clear, the beams of searchlights
would have been less visible."

and time table was kept of all ships in a given area, with
estimates of their cargoes gained by the examination of
loading operations. Photo interpreters made many kinds of
studies of proposed invasion areas. Three dimensional scale
models of beachheads were built, so detailed that com-
mandos could visualize beforehand the appearance of the
strongpoints they were to attack, and plan where to take
cover. Tank commanders were given maps showing where
their vehicles could be driven without bogging down in
marshy soil. Engineers were provided with measured draw-
ings of bridges so that they could bring parts already made
to repair them, should they be blown up by the enemy.
Sometimes it was even possible to see on the photograph
the very demolition charges which had been placed on the
bridge in preparation for its destruction.

Landing areas for dropping agents by parachute were
chosen by studying air photographs, and the reports of

agents were verified by the camera's evidence. To Army engineers the report that locomotives were crossing the Corinth Canal in Greece by a pontoon bridge seemed absurd: no pontoon bridge, they said, was capable of carrying such tonnage. Photographs were furnished; from them, the unique bridge was measured and described.

The techniques of photo interpretation are simple: the careful comparison of photo coverage over days, weeks and even months; the use of stereo vision; the measurement of images to the tenth part of a millimeter with a high-power magnifier fitted with a graticule; and, above all, visual imagination. The shadows cast by objects often reveal their profiles. Interpreters gradually became used to the view of the earth from directly above. To a good photo interpreter the identification of everything in the photograph became a challenge; "I don't look for things; I let the photographs speak to me," one of them once said. To search for unknown installations requires much ingenuity and imagination. Photographs of Peenemünde, a village in the Baltic, were taken in 1942; interpreters were puzzled by what appeared to be heavy constructional work. A year later ground reports indicated that the Germans were building some new secret weapon at this very pinpoint. New photographs were taken. They showed two rockets, and a strange tower. With this clue, the earlier photo coverage was again studied, and it was possible to reconstruct the entire complex of the launching site of the V-1 and V-2 bombs. From this knowledge, many other bomb launching sites, hidden in farmyards and within orchards along the French coast were identified and pinpointed for attack.

So keen were the eyes of the Army that the enemy took countermeasures to foil the photo interpreter. The Germans put bridges on rollers beside Italian rivers; by day they hid them beneath trees, by night they rolled them across the river. These concealed bridges were discovered when planes equipped with flashbombs photographed them at night. Attempts to imitate aircraft were made by digging away snow in the form of wings and fuselage of aircraft in the hope that photo interpreters would give false estimates of the enemy's air strength. Once a photo interpreter was studying the ruins of an aircraft factory in Germany that was apparently totally demolished by allied bombings, and had been written off as inactive. At the very edge of the rubble he saw the sharp-outlined wing of an airplane. New photographs were taken: studying them he soon deduced that the Germans had built a new factory directly beneath the ruined one; the camouflage was almost perfect.

Photo intelligence as developed in World War II still continues. It was unfortunate that President Eisenhower's plan to use photo reconnaissance as a means of keeping the peace was not accepted. The "Open Skies" program which he proposed at the Big Four Summit Meeting in Geneva on July 21, 1955, would have produced routine photo coverage of the world, so that each nation would know what the other nations were doing. President Eisenhower had hoped that this mutual surveillance would provide necessary security for a realistic disarmament plan.

To cover such vast areas as the President envisaged in his "Open Skies" program, photographs would have to be taken from extremely high altitudes, far beyond the 25-to 40,000-foot altitudes of the World War II photo planes. The fact that reconnaissance planes were making overflights of Russia became public knowledge when the Soviets brought down the U-2 plane of Francis Powers in 1960. Such improvements have been made in lenses, cameras and film, that photographs taken at 60,000 feet show even greater detail than the typical reconnaissance photographs of World War II.

Air photography, perfected for military purposes, has been put to peaceful purposes. The science of photogrammetry — the precise measurement from photographs of the earth's surface in three dimensions — has revolutionized our knowledge of the world.

# 12 MAPPING THE WORLD AND EXPLORING THE PAST

The tools of the photogrammetrist were invented at the turn of the century, so that not only the length and the breadth of the earth's surface could be measured from air photographs, but its height as well. The precision of maps made this way was found to be remarkable: measurements were proved to be accurate to a factor of 0.06 percent. Little use was made of this new skill, however, because of the difficulty of obtaining a sufficient number of overlapping photographs exposed from the same height, equidistant from one another, and exactly covering the area to be mapped. Although the altitude of a free balloon can be maintained, the path of its flight is unpredictable. Better success was obtained from dirigibles, but the best camera platform proved to be the airplane, as perfected during World War I.

Col. T. E. Lawrence, fresh from his legendary exploits in Arabia, envisaged what was to come: in a letter to *The Daily Telegraph*, London, October 30, 1920, he wrote:

"Some experiments have been made during the last year in map production by air photographs. It can be shown that for scales of 1-2,000 to 1-50,000 air photography has cheapness, accuracy, speed, and increased detail. Air photographs are taken at a height of 10,000 to 15,000 feet, the plates having a tilt to the horizontal not exceeding 5deg or 10deg — the more horizontal, of course, the better. There must be an overlap of 30 per cent over each plate, preferably of 50 per cent. Each plate will cover perhaps two square miles, but with 50 per cent overlap, only about one square mile is accepted from each negative."

By such a technique, Lawrence stated, an enormous amount of time would be saved: "in an hour's flight almost 100 square miles can be covered." He cited a map of Damascus, on a scale of 1-5,000 made in 31 working days at a cost of £50. "Three Italian engineers took three years to produce a map on the same scale with much less detail, at a probable cost of well over £6,000."

Lawrence suggested that the flying be done by the Royal Air Force. "In the first place it gives their personnel, who are young, keen, and only too anxious for some useful work, a practical and definite object in flying with certain conditions to fulfil. After they have been of such enormous practical value in the war, it is sometimes depressing to them to have only a few aimless practice flights. Secondly, the art of photographing country requires training, and in war time has proved invaluable. . . . The Air Force, too, must keep its photographic plates and material ready for war purposes. These require renewing every few months, especially in hot climates. Hence let them be used on some definite practical plan of value to the State."

He realized that the simple photogrammetric technique which he outlined was limited to the mapping of level terrain, and suggested that experiments first be made in Egypt and Palestine. "As for surveys in Australia, Canada, India, the air photographer and the surveyor between them have a huge field in the Empire, and any other country, such as China or Argentina, requiring land registration for taxation purposes or other mapping would save time and money by adopting the method. The present need is for further research, a small outlay, and co-ordination between surveyors and the Air Force."

*The British Journal of Photography* was most skeptical. "Our own view is that the value and economy of the aerial photographic method for accurate map making is still unproved. What is wanted is an investigation of its possibilities which can be done in the laboratory and by the mathematician, and does not require, as Col. Lawrence suggests, the using up every few months of the photographic material which, in his view, the Air Force must keep ready for war purposes." The strongest criticism came from the Aircraft Manufacturing Co., Ltd., which was already in the air survey business. After pointing out certain technical flaws in Lawrence of Arabia's argument, the writer came to his

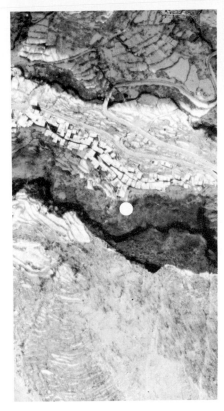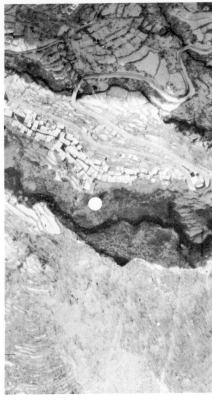

Hill town in Northern Italy.
Stereo pair with floating
mark superimposed.
Royal Air Force photos.

main objection, which was economic: "We think it advisable that civil problems should not be bound up with military problems, as they are entirely different . . . The article . . . is not helping commercial aero-photographic work. There are in this country today perhaps three or four companies whose existence depends on aerial photographic work, and the publication of figures such as those relating to the cost is apt to have a very detrimental effect on their business. . . ."

The maps envisaged by Col. Lawrence were drawn from photographs pasted down one beside another to form what is called technically a "mosaic." As he pointed out, such maps are accurate only when the terrain photographed is flat. In mountainous areas the ground may be several thousand feet closer to the airborne camera than the sea coast, and consequently distances upon them will appear in larger scale.

Through the use of stereoscopic vision heights above and below areas of known altitudes can be measured from overlapping photographs, and contour lines of mountainous terrain can be accurately plotted. Several instruments have been designed for this purpose, all based on the principle of the "floating mark," discovered in 1892 by Franz Stoltze, a

photographic scientist, theoretician and manufacturer of photographic paper.

A typical stereo pair consists of two seemingly identical photographs. Actually they differ slightly, just as the image formed on the retina by the right eye differs from that formed simultaneously by the left eye, due to the difference in viewpoint between the eyes. Viewed through a stereoscope*, the photographs reproduced above will appear in sharp relief. The hill town hangs precariously above a deep gorge. The distance between homologous points at the bottom of the gorge is 52 mm. The distance between the images of the same building on the rim of the gorge is 50 mm. On the photograph we have superimposed two white dots: the distance between their centers is 50.8 mm. Through the stereoscope these two dots fuse, to appear as a single dot floating in the gorge. If we change the separation of these superimposed dots, the floating mark will rise and fall, and seemingly touch any terrain feature; if we know one height, we can measure all the others by a simple mathematical calculation.

* A photo interpreter's stereoscope may be obtained from Air Photo Supply Corp., 158-G South Station, Yonkers, N. Y.

Multiplex stereocomparator.

The simplest "stereocomparator," as such a measuring device is called, consists of a simple twin-lens stereoscope with two pointers, one of which is fixed, the other movable by a precise micrometric screw action. When the pointers are adjusted to touch exactly two homologous points on the terrain, such as the top of a mountain or the cap of a chimney, the distance between these points, recorded on the micrometer, provides the measure of the mountain's, or the chimney's, height.

Other instruments enable the photogrammetrist to trace maps. One of the most popular is the "Multiplex" stereocomparator, designed by the Carl Zeiss optical firm of Jena in 1934, and manufactured in the United States by Bausch & Lomb of Rochester, N.Y. It consists of a battery of projectors resembling photographic enlargers above a table. Positive transparencies, made from the air camera negatives, are put in the projectors. The height of the projectors and the distance between them is adjusted, so that the system reconstitutes, on a reduced scale, the flight.

Every other image is projected through red glass; every alternate image through blue-green glass. The photogrammetrist wears spectacles of red glass for one eye, blue-green glass for the other eye. Thus, with one eye he sees only the red images and with the other eye only the blue-green ones. The requirements of stereo vision are fulfilled, and the terrain lies in miniature in its three dimensions. Though this image exists only in the mind of the beholder, it seems solid and real — so real that photogrammetrists insist upon calling it "the model" and treat it as if it were an objective thing instead of an impalpable illusion.

The model can be touched, as it were, with a single, brilliant point of light, which acts as a floating mark. The exact position of the floating mark in three dimensions determines the position in space of the terrain feature which it seemingly touches. The height of the floating mark can be varied: if it is adjusted to coincide with terrain of known altitude, every other part of the model which it touches is of the same height. The point source of light which forms the floating mark is on the top of a table which has agate feet so it can easily be pushed around. Set directly under the light is a pencil which just touches drawing paper laid flat on the surface on which the images are projected. The photogrammetrist, by guiding the floating mark around shore lines, rivers, roads and other terrain features, literally traces them upon the drawing paper. By setting the floating mark at given altitudes he can easily produce contour lines.

With more sophisticated apparatus, the floating mark is connected to a remote pencil by a system of levers forming a pantograph. The scale can be altered as desired by changing the points at which the levers pivot.

For accuracy, air photographs made for cartographers should be taken with the focal plane of the camera abso-

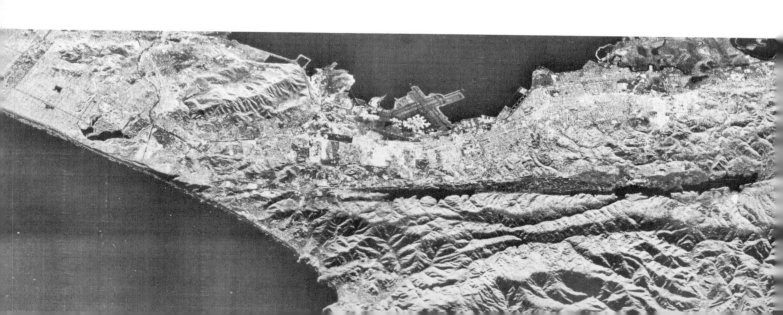

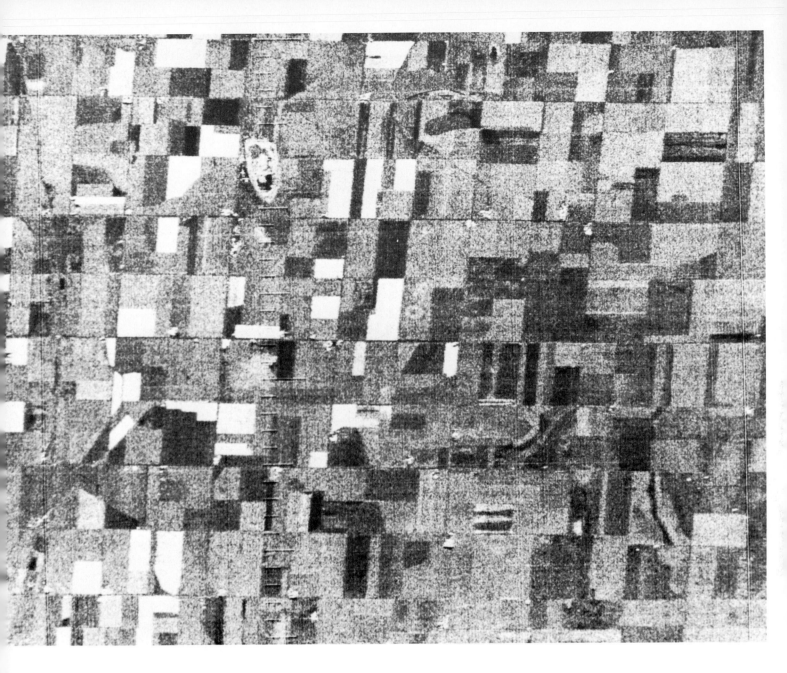

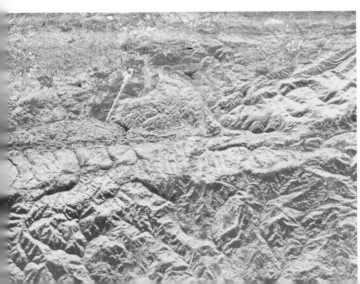

Radar photograph of the San Francisco Peninsula penetrates beneath surface soil and vegetation to reveal the San Andreas seismic fault. Left of center is the San Francisco International Airport. Towards the right hand edge is the linear accelerator of Stanford University. NASA photo.

Ancient earth-works at Chillicothe, Ohio, drawn by John Wise from his balloon in 1852. No trace could be found of them on the surface of the ground.

lutely horizontal. It is, however, seldom possible for an airplane even in peacetime to fly truly straight and level. Therefore, the negatives are corrected, or "restituted," in printing the positives for the stereocomparator. If the exact land distances of a number of landmarks are known, the negatives showing them can be tilted one way or another in a projection printer until their images correspond to their known position on the ground.

Almost all of Europe and North America has been mapped by the air camera, and air surveys are now being made of South America, Central America, Asia, and Africa. The effort is international, for the air camera knows no boundaries save those that are political. Nigeria is being mapped by aircraft based in Canada, and uncharted areas of Guatamala are being photographed by a German air survey company. Photogrammetry is by no means limited to this planet: from stereo pairs obtained by the Lunar Orbiter spacecraft, contour maps of the mountains of the moon have been made by photogrammetric techniques.

Besides enabling us to make maps of what now is visible on the face of the planets, air photography makes visible the past of mankind. Any disturbance of the earth's soil leaves its mark forever; crops growing in filled-in trenches differ in color from those growing in less-disturbed soil. Although invisible from the ground, these marks can clearly be seen from the air. The American balloonist John Wise, on his 132nd ascension, over Chillicothe, Ohio, in 1852, saw what he first thought to be mathematical figures or hieroglyphics traced in the soil. "Could it be a delusion?" he asked himself. "No, I was only moderately high then — 3000 feet. I viewed it and reviewed it, and it must be in the soil, if it is not actually a raised line in the form of a bank over the general level. On my return home I learned from the citizens that there are traces of ancient fortifications thereabouts, and this at once revealed the mystery. . . . The appearance of these outlines in the soil shows how the power of vision is increased by looking down upon the earth from balloon height. I made it a point to go over the ground where these figures appeared, but could trace no outlines, although what I saw from above must have been the result of color in the soil. It is not an uncommon thing to notice this remarkable phenomenon of vision when sailing over the earth."

Although kite photographs of archaeological diggings on the Upper Nile were made in 1910, the full potential of air photography to archaeologists first became evident during World War I, when Col. G. A. Beazeley discovered cities in Iraq whose ruins were unintelligible when viewed on the ground. In 1922, Air Commodore Clark Hall noted marks on Royal Air Force photographs; he brought them to the attention of O. G. S. Crawford, archaeology officer of the official British Ordnance Survey, who identified them as prehistoric field systems near Winchester, and was able to make maps of them. Later Crawford and Alexander Keiller rented a plane to fly archaelogical surveys: the result was the classic book, *Wessex from the Air* (1928), which gave wholly new information about the activities of the Romans in ancient Britain. Crawford explained that air vision did not truly reveal the invisible; it enabled the earth to be viewed in a different way. He made a simple comparison: "If one looks through a magnifying-glass at a halftone illustration made through a coarse screen, it ceases to be seen as a picture and becomes a meaningless maze of blurred dots. If one holds it at some distance off and looks at it with the naked eye, it becomes a picture again. The observer on the ground is like the user of the magnifying glass; the observer (or camera) in the air resembles him who looks at the picture from a distance."

Air photography has become an indispensable tool in our civilization: the list of those who depend upon its revelation becomes greater as the quality of photography improves.

Indian pictographs 30 miles north of Blythe, California. The figures are of such vast scale — the man is 167 feet tall — that they were not known until this photograph was taken in 1932 by a U.S. Army Air Force plane.

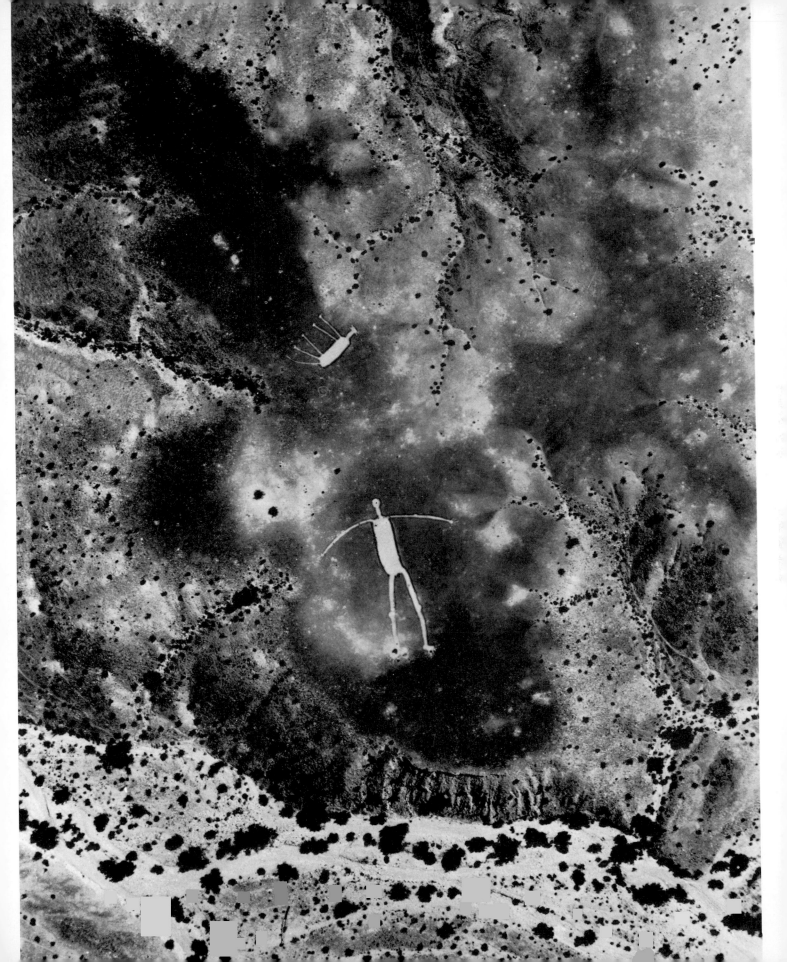

The geographer can study untracked terrain with astonishing clarity. He can plot the pattern of ice floes in northern waters and deduce the causes of floods.

The civil engineer can choose sites for bridges and dams, routes for highways and railroads and ship canals.

The city planner can measure the density of housing and the best location for new buildings, open squares and parks.

The forester can estimate crops by species, spot the outbreak of fires in remote areas, and — by using infrared film — separate the deciduous trees from the conifers, even in summer.

Traffic engineers can compare the flow of vehicles at various hours of the day.

Geologists can locate hidden faults, landslides, and areas for the prospecting of oil.

Conservationists can spot herds of wild animals; every year the seals of the Canadian North are counted head by head.

The tax gatherer can measure land ownings without the surveyor's rod and link. . . .

The uses of the airborne camera are constantly expanding, and with the development of new photographic techniques its scope has greatly enlarged. It has long been known that infrared radiation can be recorded by photographic emulsions: now special color film shows these rays as red along with the "true" colors of visible light rays; originally produced during World War II as a means of detecting camouflage, this technique has proved to be of great value in the study of vegetation. Great advances are being made in the formation of visible images by radar: the earth is scanned and the reflected beams are made visible on a cathode ray tube, which is then photographed. Earthquake faults stretching the length of northern California have been revealed by this technique in a way that cannot be equalled by direct photography, since radar penetrates vegetation upon the surface of the earth, bareing the basic structure beneath. It is even possible to record heat waves on film. Seemingly there is no limit to the evidence that the airborne camera can collect.

Wheat harvesting, Manitoba, 1958.
Lockwood Survey Corporation
Limited, Toronto, Canada.

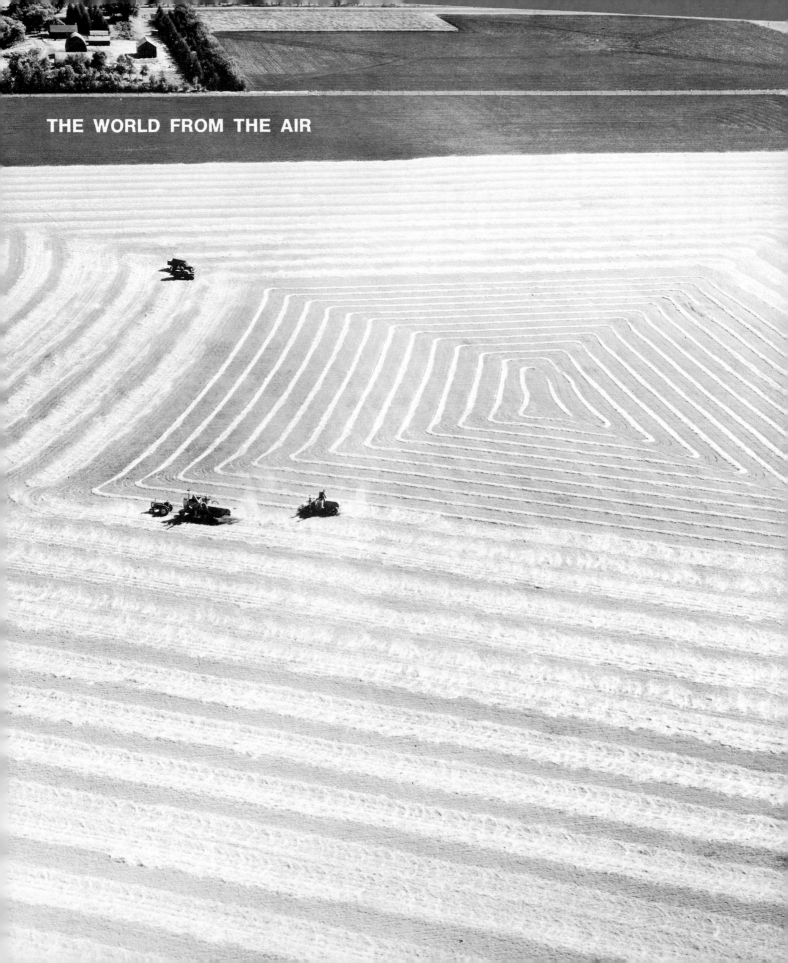

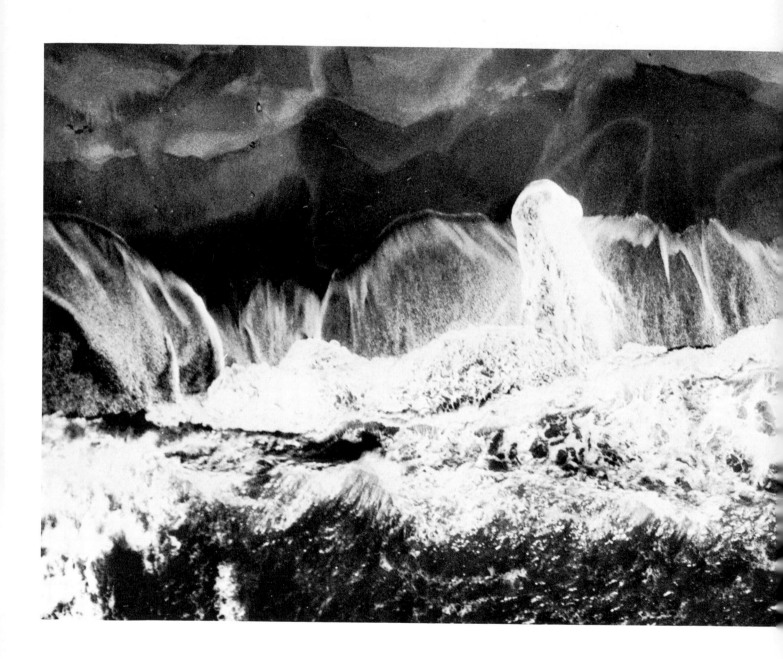

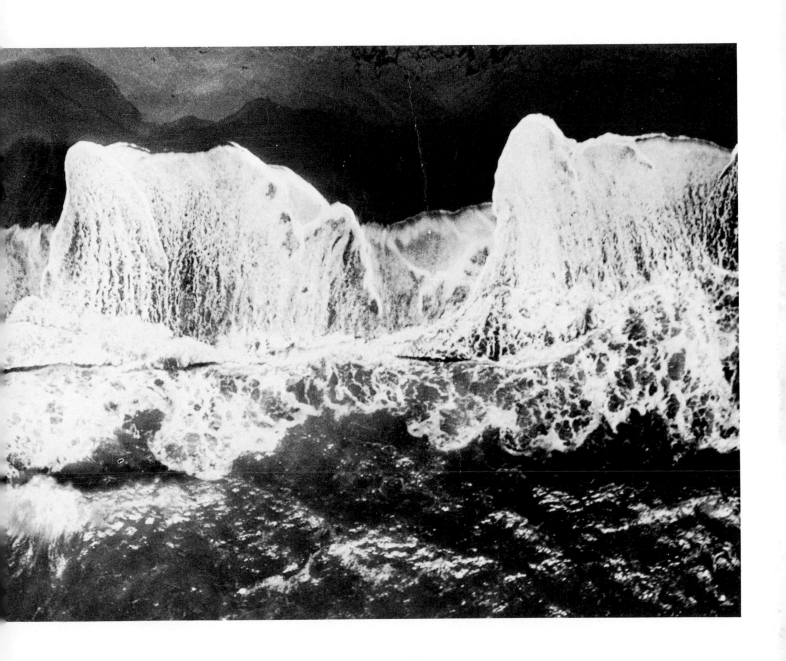

Surf at Point Reyes, California.
William A. Garnett.

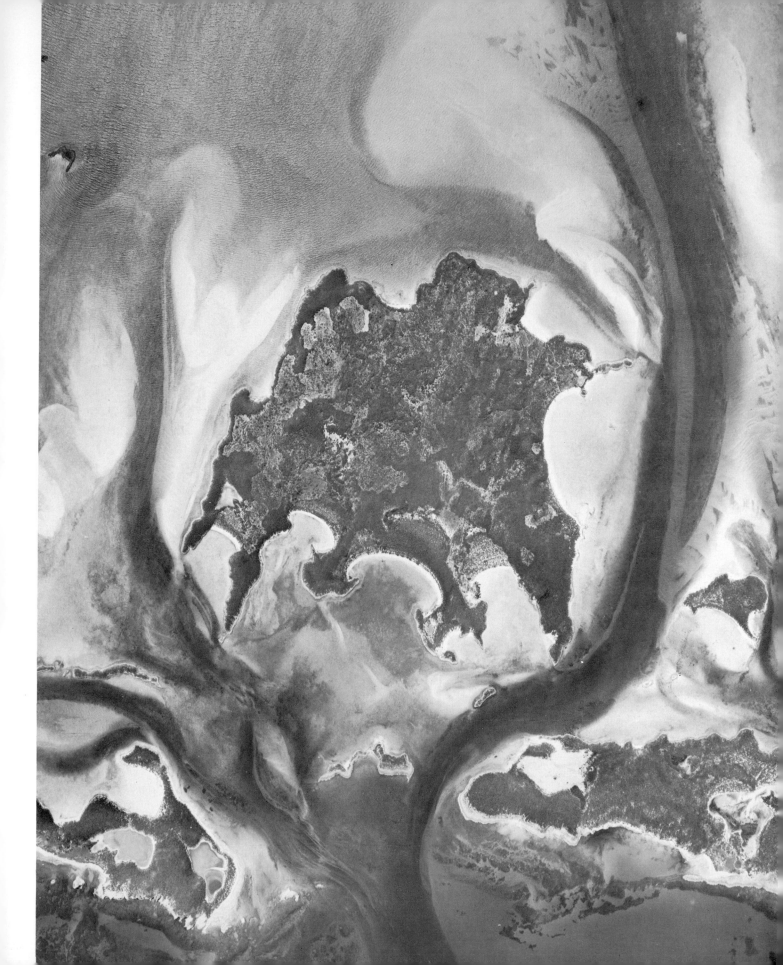

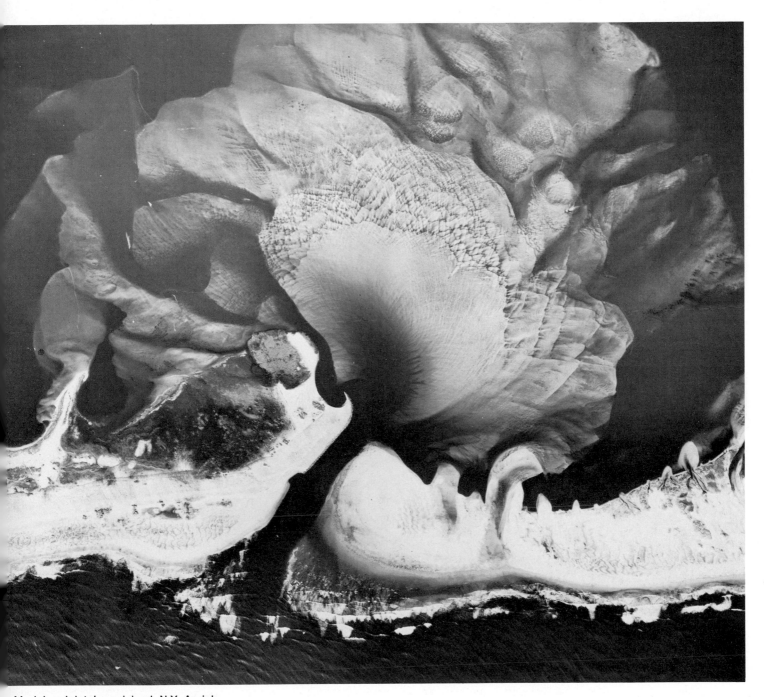

Moriches Inlet, Long Island, N.Y. Aerial
photographs reveal underwater sandbars
invisible from the surface.

*Left:*
Exuma Cayes, Bahama Islands
Lockwood, Kessler & Bartlett, Inc.,
Syosset, New York.

75

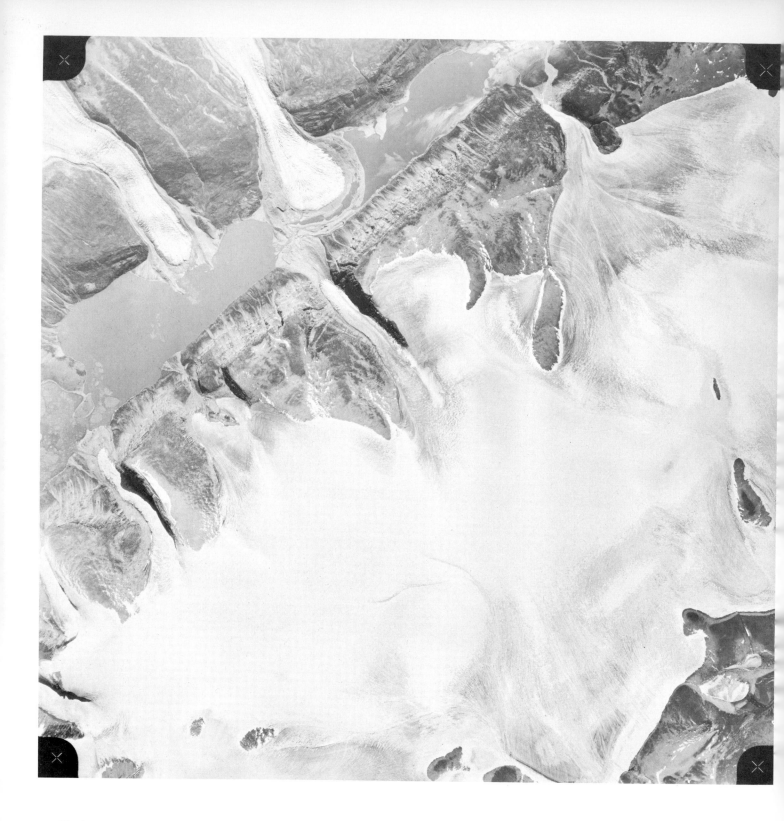

Glaciers.
Lockwood Survey Corporation Ltd.,
Toronto, Canada.

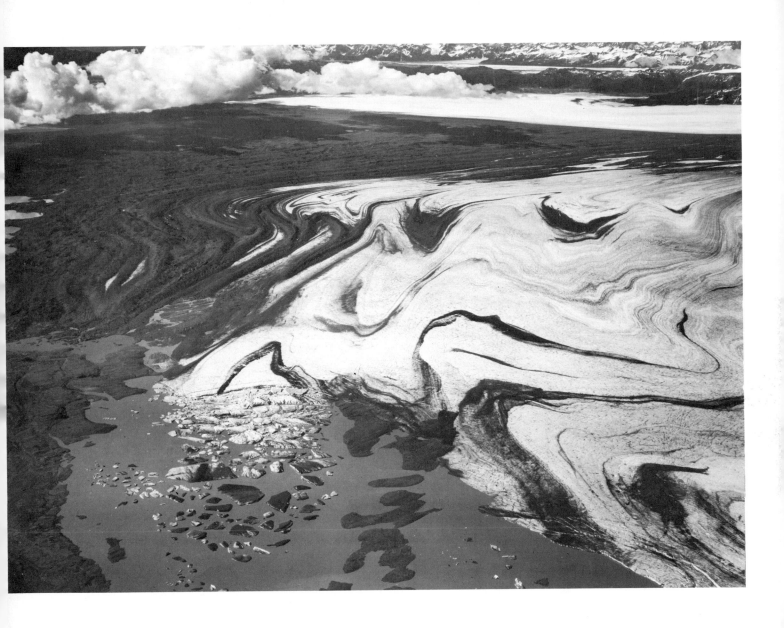

Lakes and stagnant ice at snout of
eastern lobe, Bering Glacier, Alaska.
Bradford Washburn.

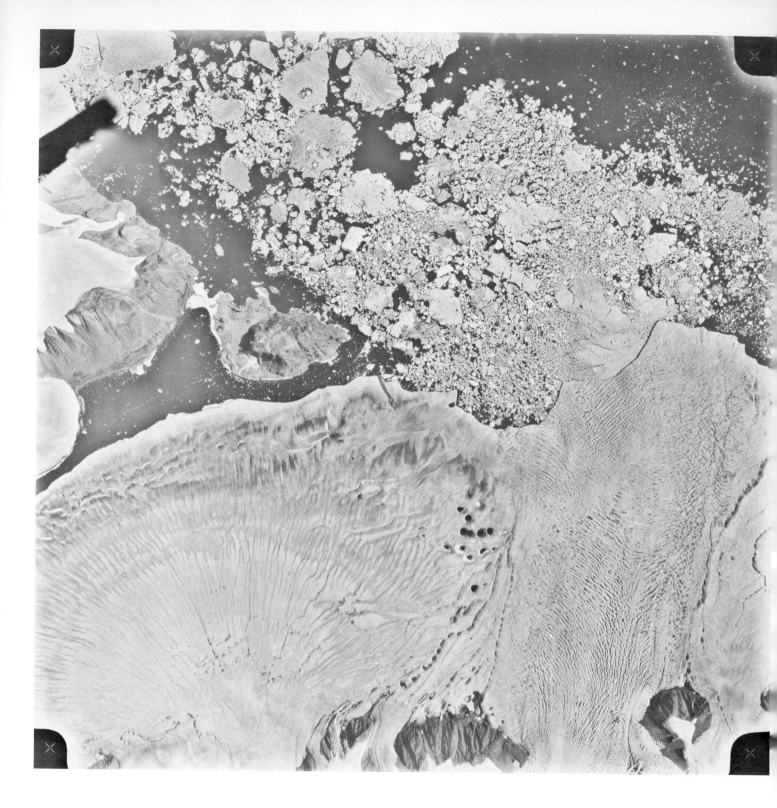

Ice
Lockwood Survey Corporation, Inc.,
Toronto, Canada.

Ice, Lake Ontario.
Lockwood Mapping Inc., Rochester, N.Y.

Butte, Marble Canyon, Arizona.
Wiliam A. Garnett.

Mount Vesuvius, Italy, after the eruption
of 1944.
Royal Air Force

Beni Abbès, Algeria.
Institut Géographique National, Paris.

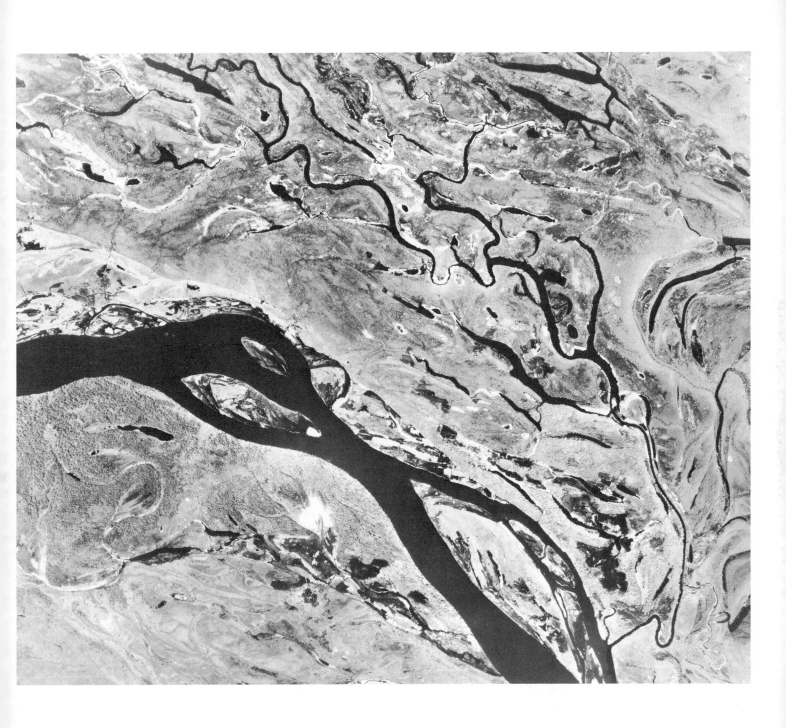

Nigeria.
Canadian Aero Service Limited, Ottawa,
and Lagos, Nigeria.

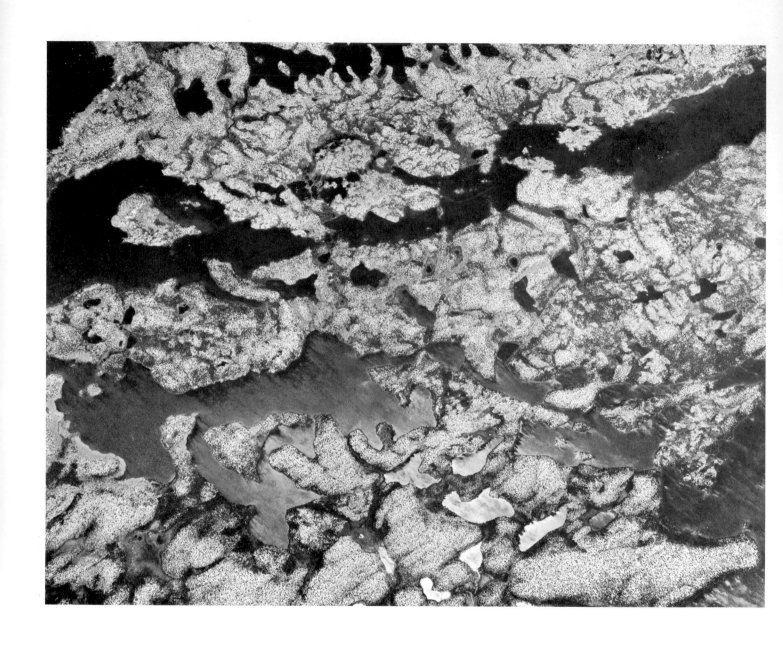

Labrador.
Canadian Aero Service Limited, Ottawa,
and Lagos, Nigeria.

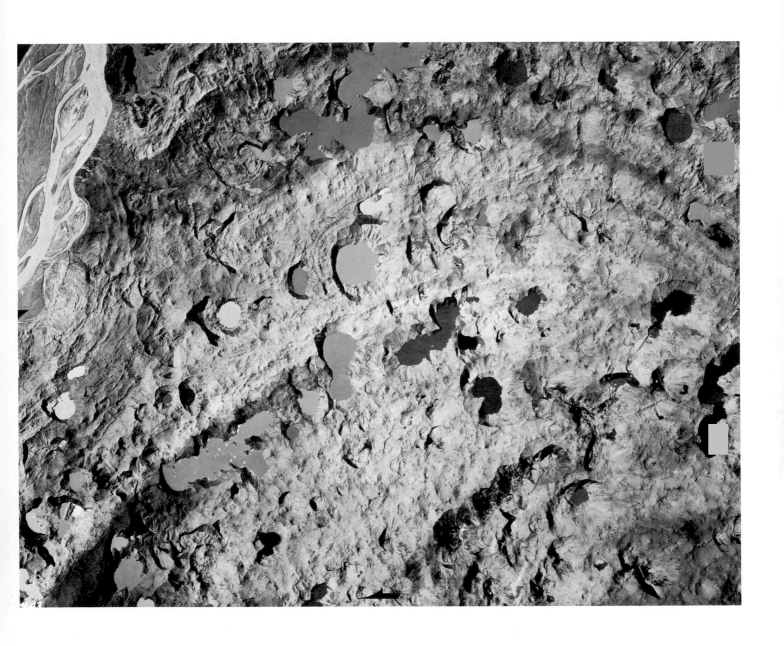

Chitina Glacier, Alaska.
Bradford Washburn.

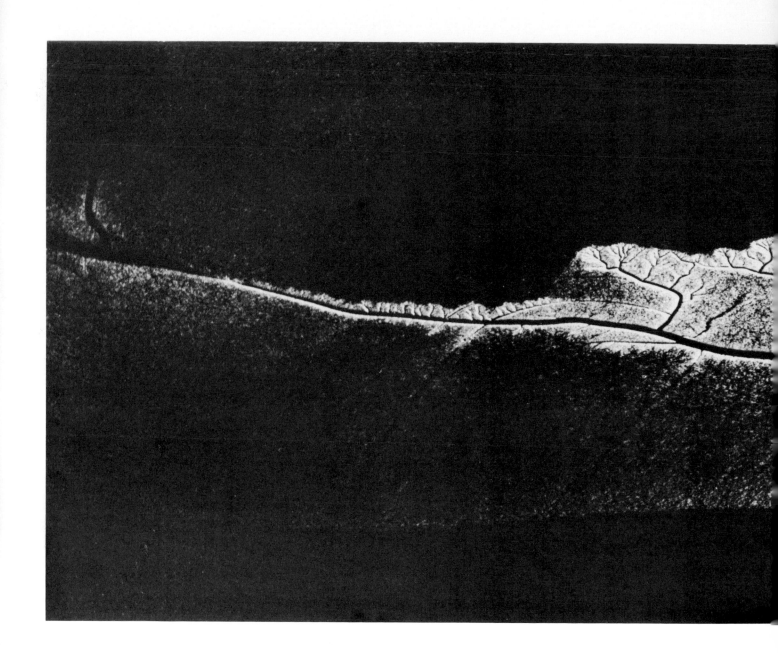

Tidelands, San Francisco.
William A. Garnett.

A tug boat, towing a log raft, stirs up
the sea bottom.
Lockwood Survey Corporation, Inc.,
Toronto, Canada.

88

Sandbar,
New England Coast.
Robert Perron.

Middle West farmland.
William A. Garnett.

90

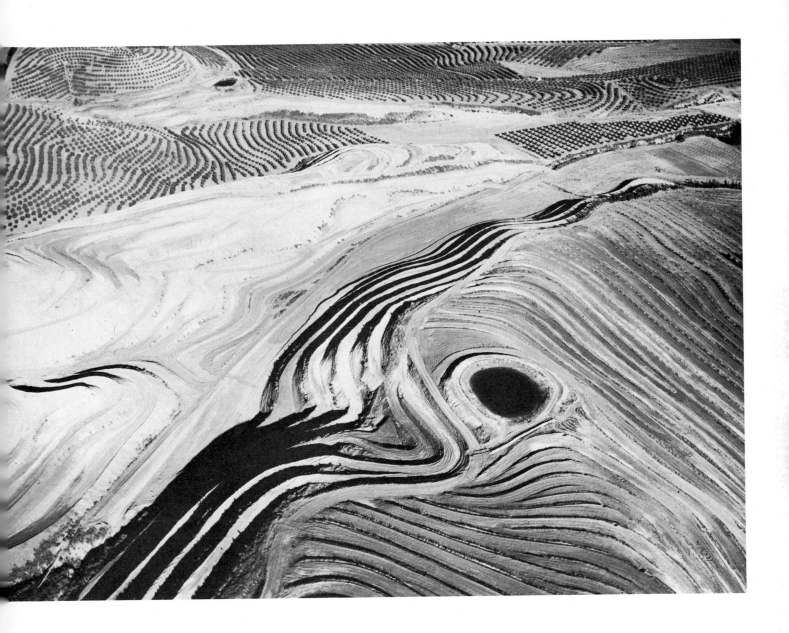

Contour plowing, Ventura County, California.
William A. Garnett.

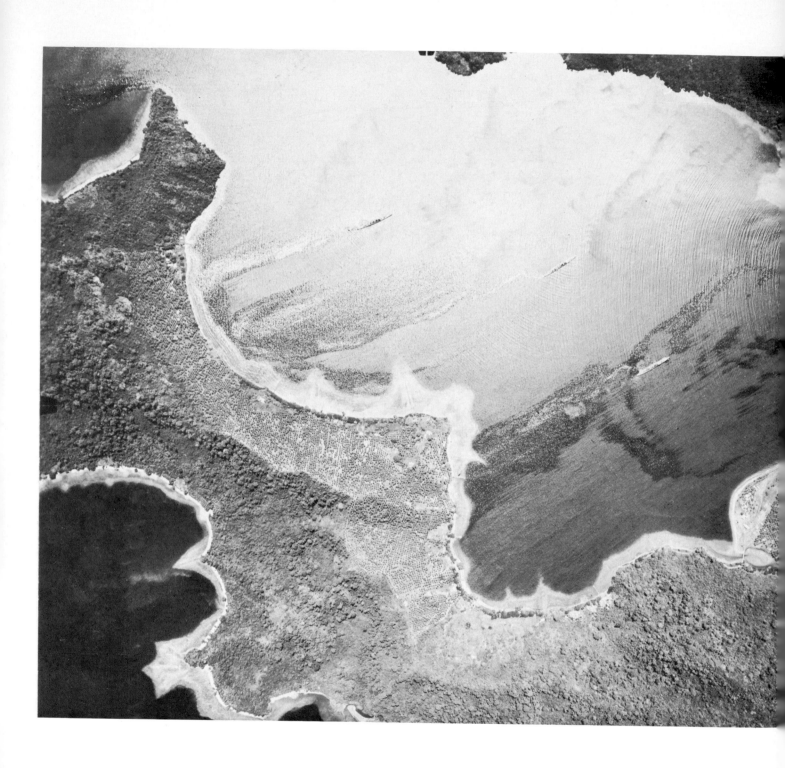

Three Japanese cruisers, Solomon Islands.
U.S. Navy.

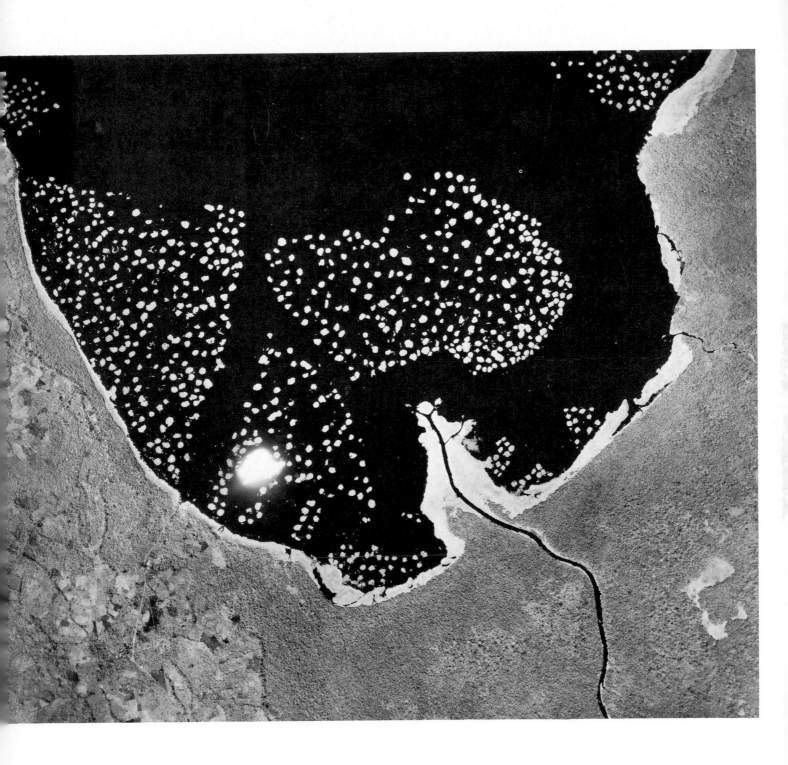

Mango trees in flood, Nigeria.
Canadian Aero Service Limited, Ottawa,
and Lagos, Nigeria.

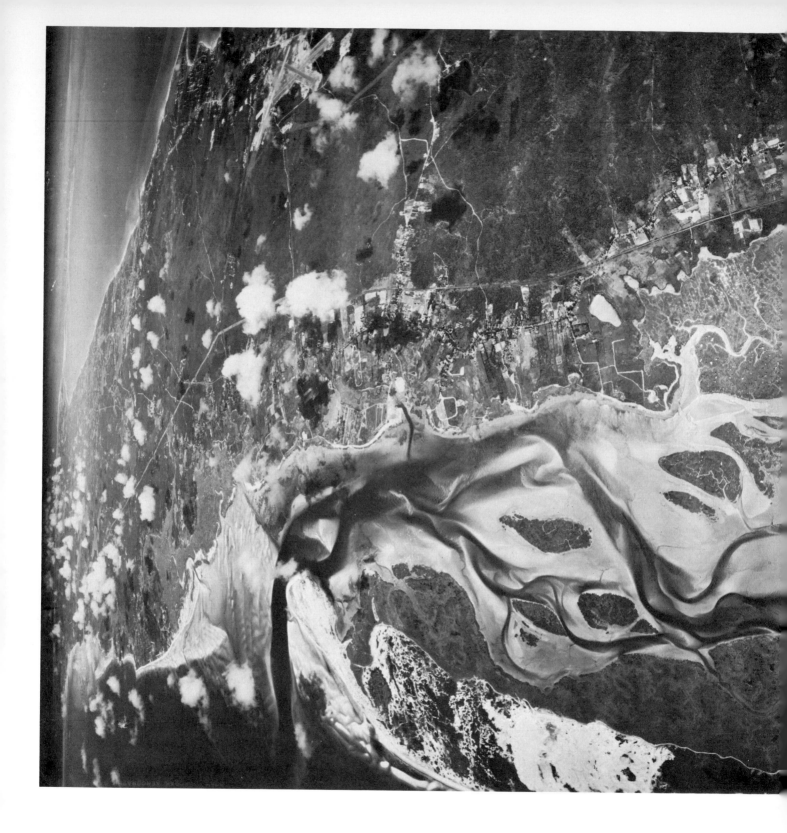

94

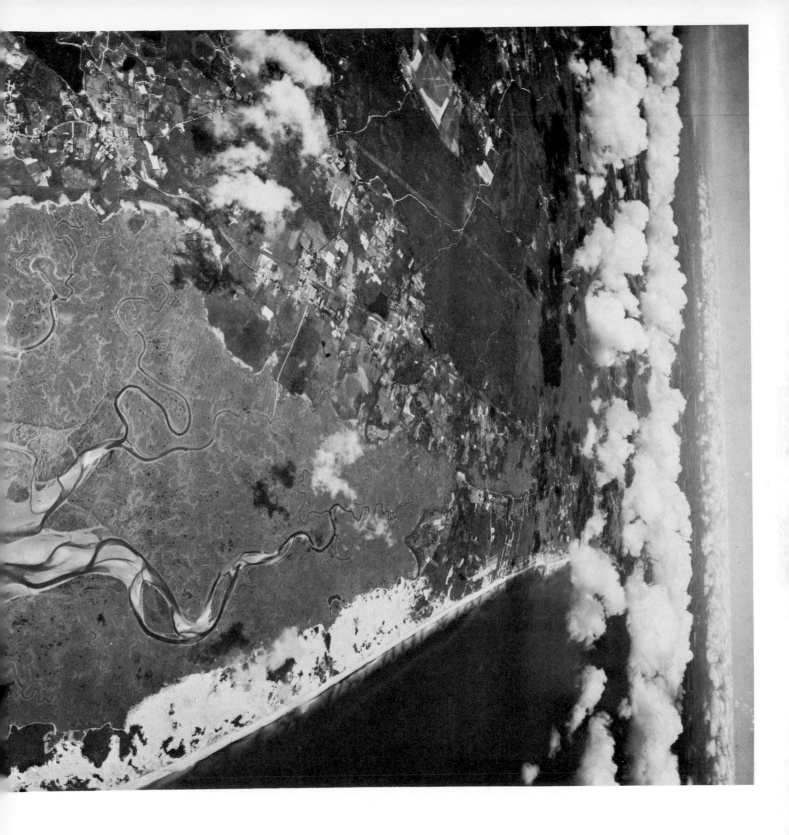

Cranberry bogs, Cape Cod, Mass.
The lens of the camera swings to cover a
180° field, from horizon to horizon.

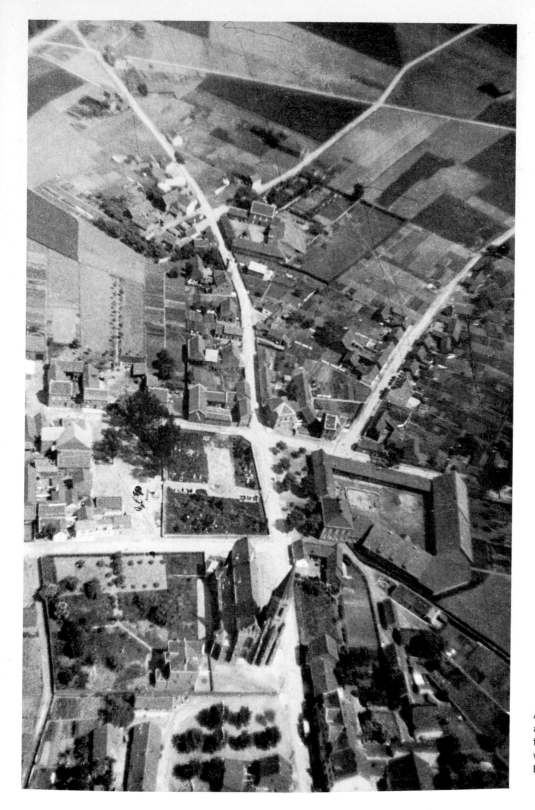

A German town, photographed by Oskar Barnack from a Zeppelin in 1913 with the prototype of the 35mm camera he invented and which was later to become famous as the Leica camera.

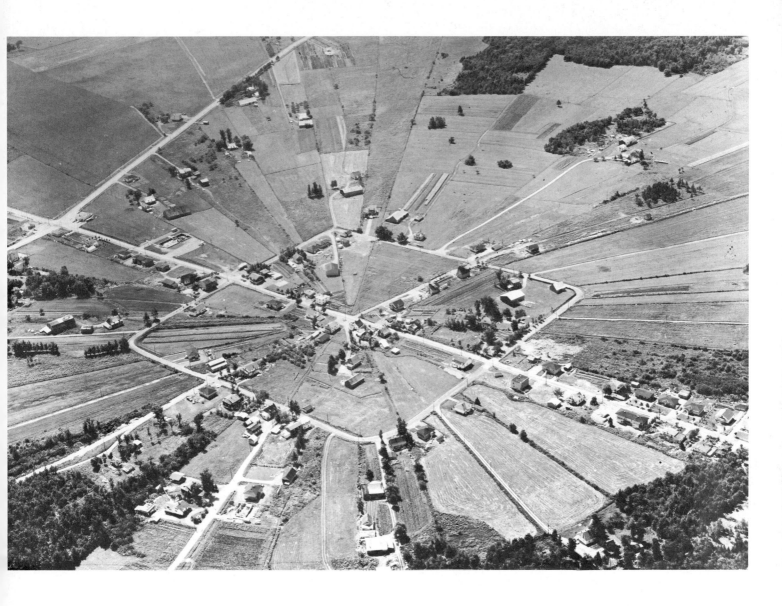

Bourg Royale, a suburb of Quebec City,
Canada.
Lockwood Survey Corporation, Ltd.,
Toronto, Canada.

Airviews often give an apparently dis-
torted view of the earth because terrain
features happen to follow a geometric pat-
tern which defies the traditional rules
of orthogonal perspective. Bourg Royale
was originally a fort in the wilderness,
with plots radiating from it to permit im-
mediate access to it, without hindrance of
fences, in case of Indian attack.

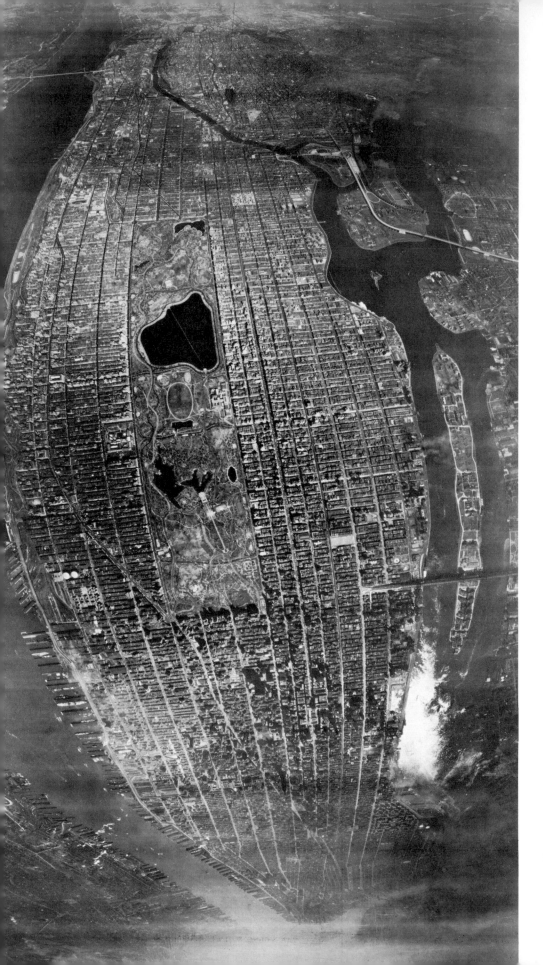

Aerial photographs may be distorted for special purposes. The airview (left) was taken with a special camera with a swinging lens to cover a strip of terrain from horizon to horizon and thus to secure a maximum amount of information. The curvilinear effect can be corrected in printing if desired. Ehud Locker's photograph of downtown Manhattan (right) was optically distorted in printing to exaggerate the verticality of the skyscrapers for expressive effect. Charles Rotkin's photograph of the same area (next page) was taken with a wide angle lens; the steep, centrifugal divergence of vertical lines gives a remarkable feeling of space, almost involving us in the sensation of flight.

Manhattan.
U. S. Air Force.

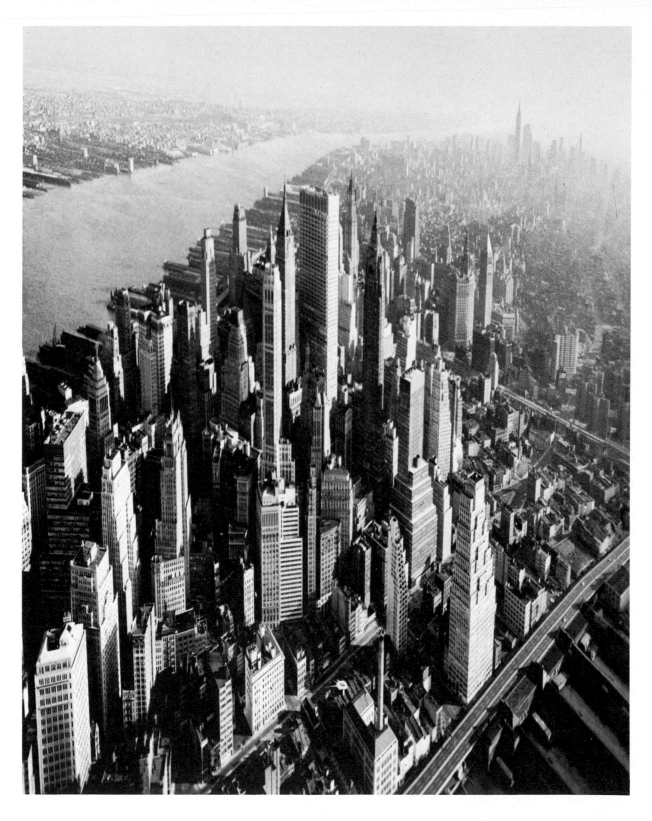

Manhattan.
Ehud Locker.

*Over:*
Manhattan.
Charles Rotkin, Photography for Industry.

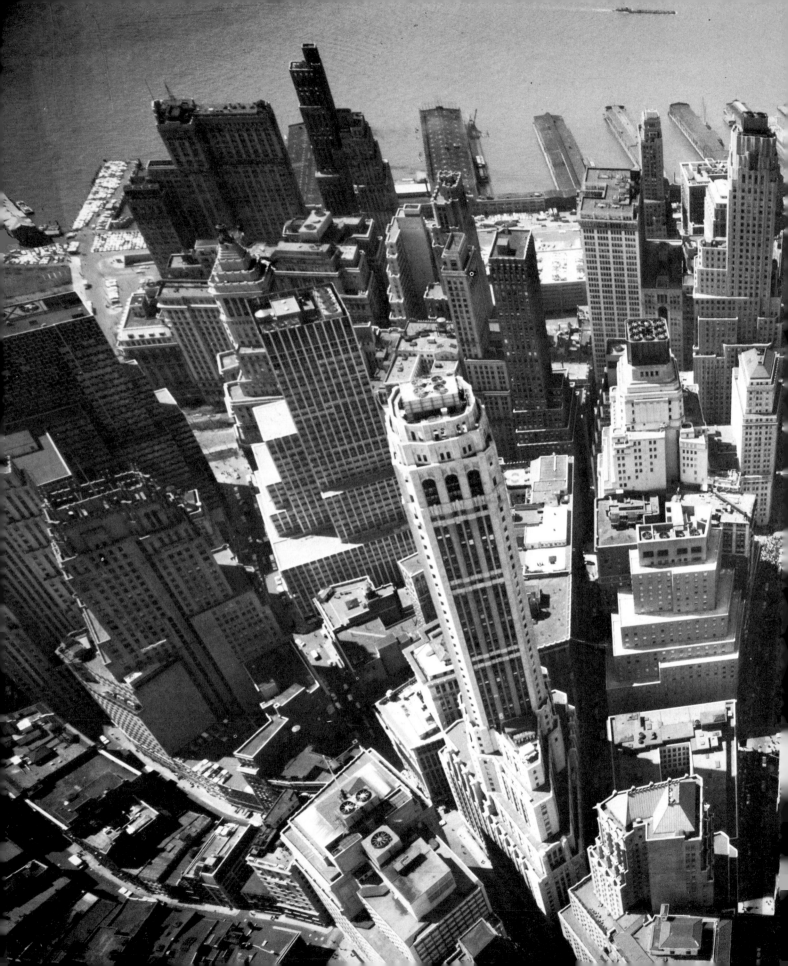

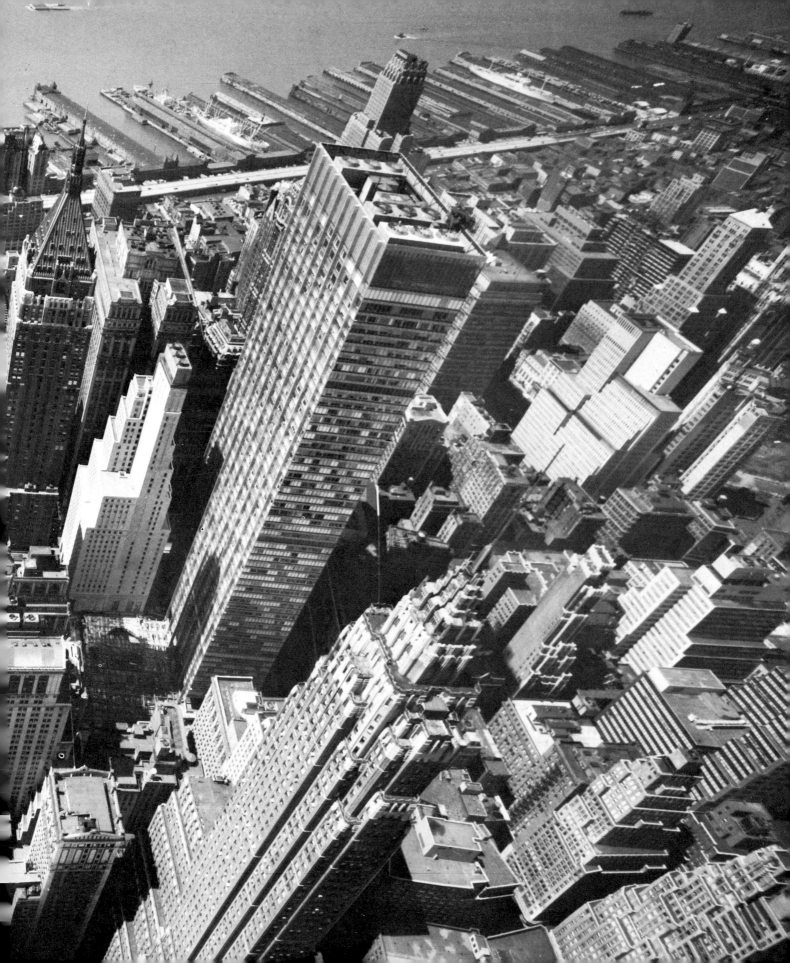

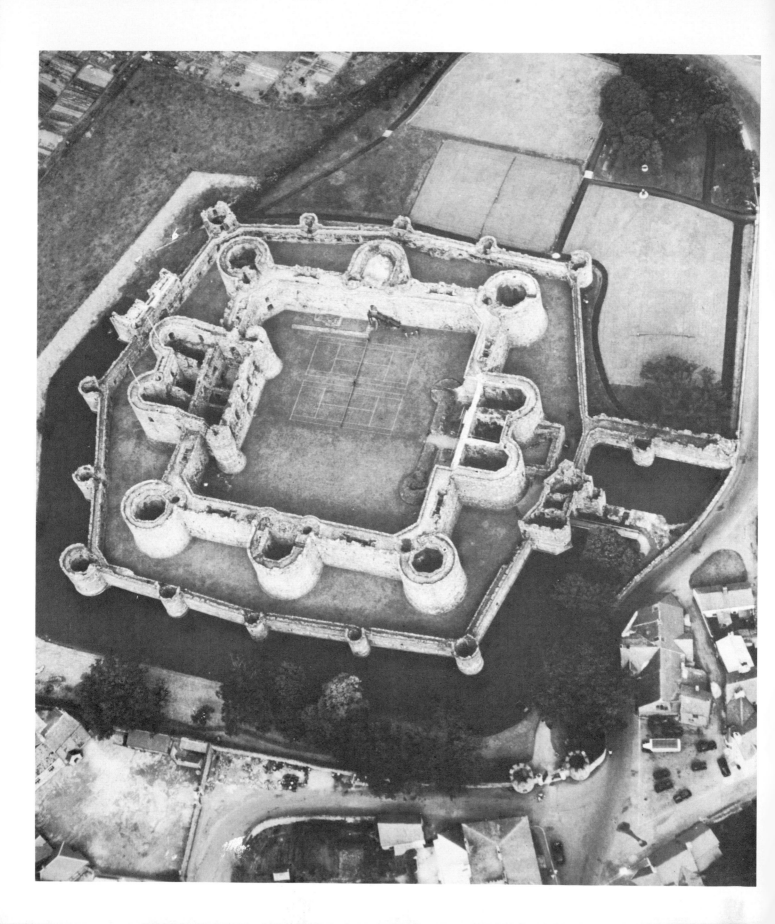

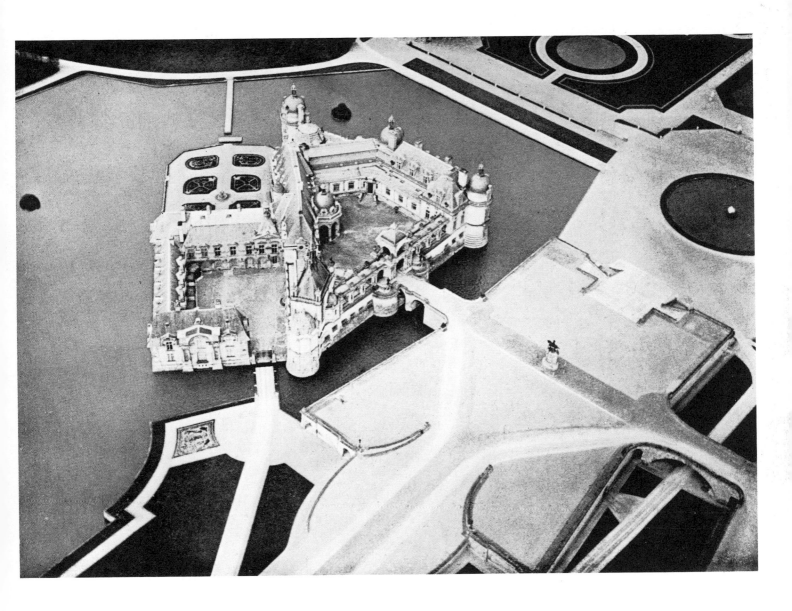

The Chateau of Chantilly, France.
Balloon photograph, about 1909.

The airview shows the plans of buildings
more clearly than ground observation.

*Left:*
Beaumarais Castle, England.
J. K. S. St. Joseph

103

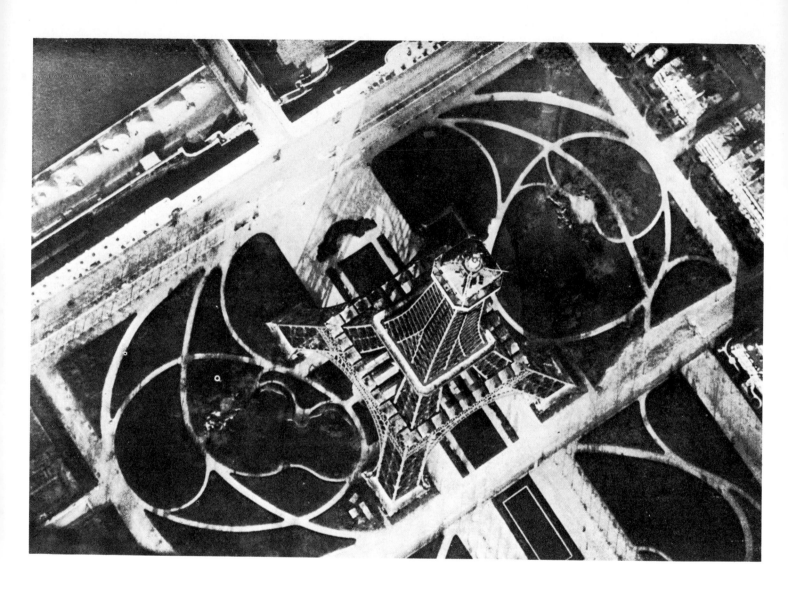

The Eiffel Tower, Paris.

*Left:* Balloon photograph, about 1909.

*Right:* Painting by Robert Delaunay.

Aerial photographs have often been compared to abstract paintings. The resemblance is not accidental, but inevitable. When painters began to experiment with the elimination of representational subject matter, or its distortion beyond recognition, they found airviews stimulating. The Russian Suprematist painter Kasimir Malevich, who exhibited in 1913 a drawing of a black square upon a white background, used aerial photographs to illustrate "the new environment of the artist" in his book *The Non-Objective World*. The architect Le Corbusier chose the 1909 balloon photograph of the Eiffel Tower (left) for the cover of his book *Decorative Art of Today* (1925): from the same photograph Robert Delaunay made the painting (right) in 1922. The Italian Futurists delighted in what they saw from airplanes. Filippo Tommaso Marinetti, who coined the name of this artistic movement, wrote: "The sky, hitherto considered man's roof, will become his pavement." He was one of a group who proposed in 1929 a new school of painting, *aeropittura,* aero-painting: they declared that "from a plane the flying painter sees the essential features of a landscape flattened, artificial, shifting, as though recently fallen from the sky."
Just as abstract painters have discovered new forms from aerial photographs, so we have learned from their paintings to appreciate the new vision revealed by flight. Even photographs taken for strictly unilitarian purposes may have extraordinary intrinsic beauty.

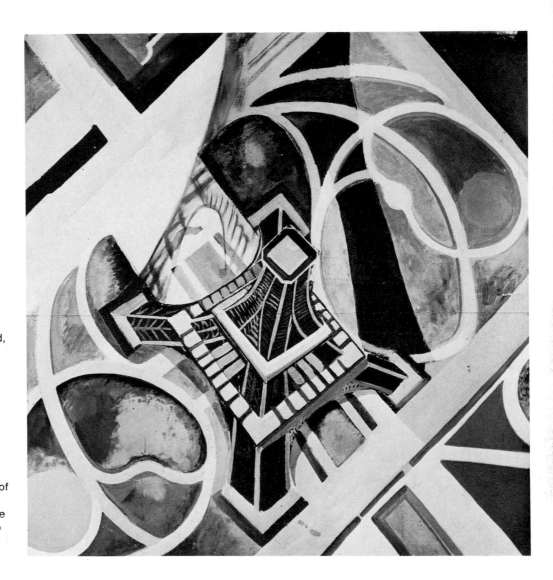

Interchange, Toronto
Lockwood Survey Corporation Ltd.,
Toronto, Canada.

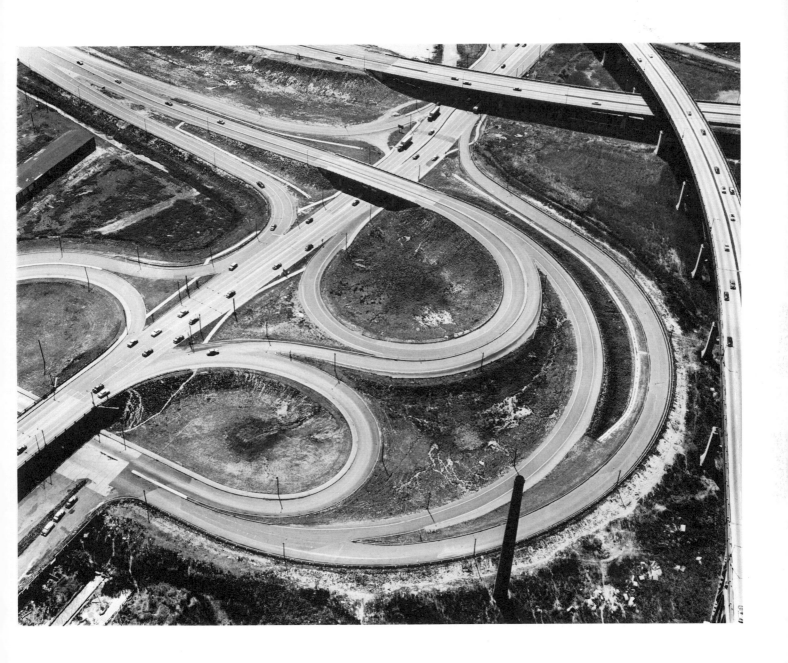

New Jersey Turnpike.
Anthony E. Linck for Cities Service.

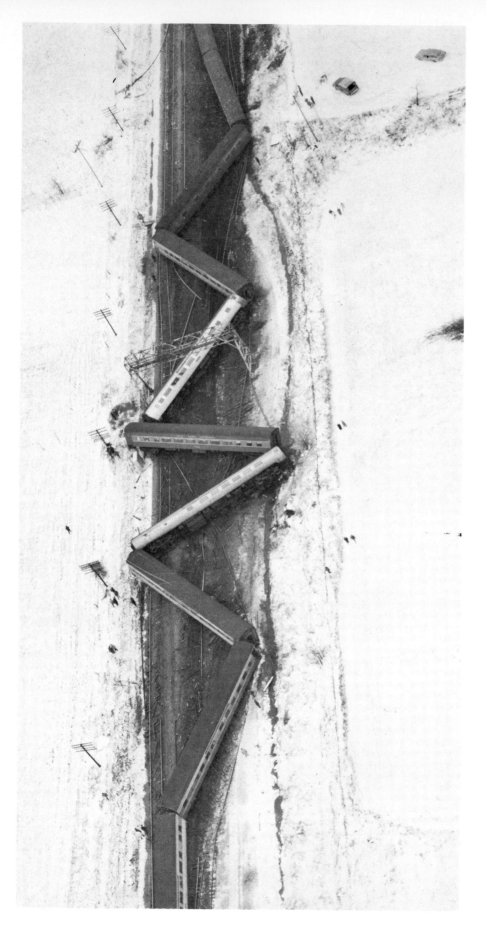

Train wreck.
Wahl's Photographic Service, Pittsford, N.Y.

New Jersey Turnpike.
Anthony E. Linck for Cities Service.

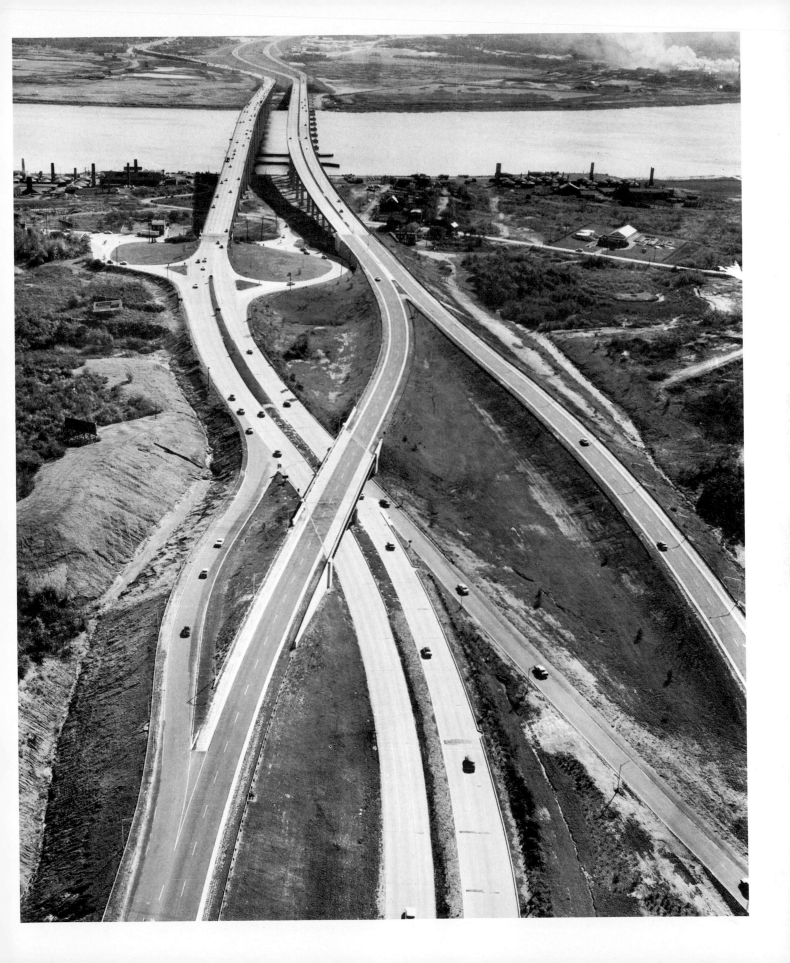

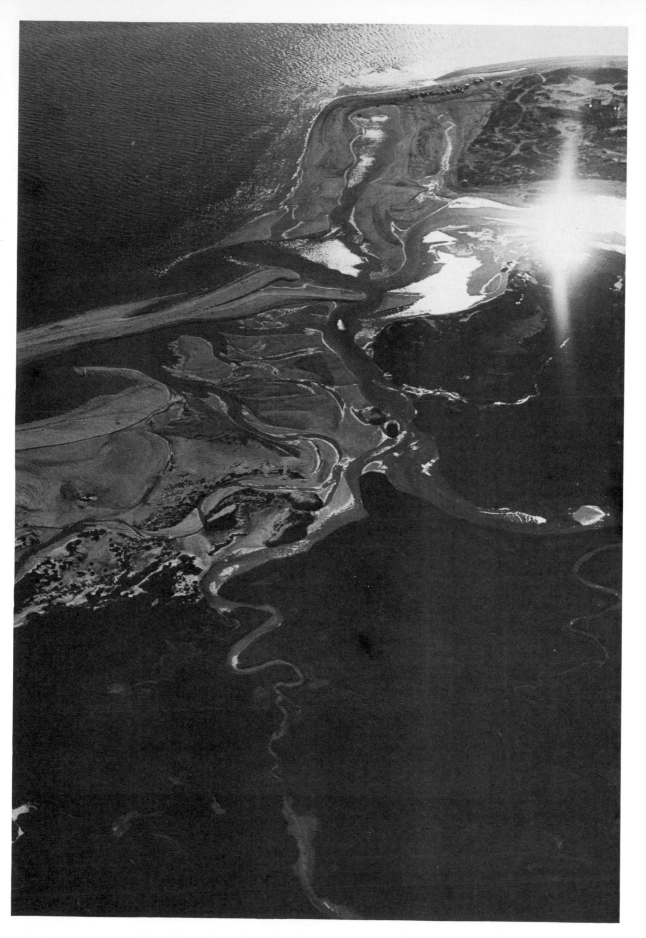

Race Point.

*Right:*
The Atlantic Ocean.
Robert Perron

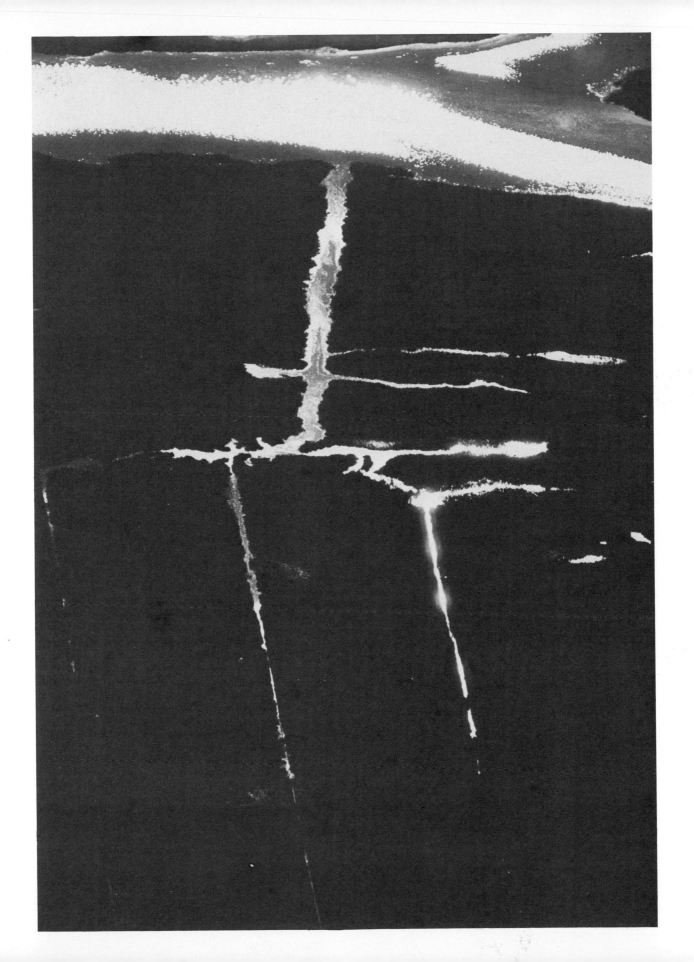

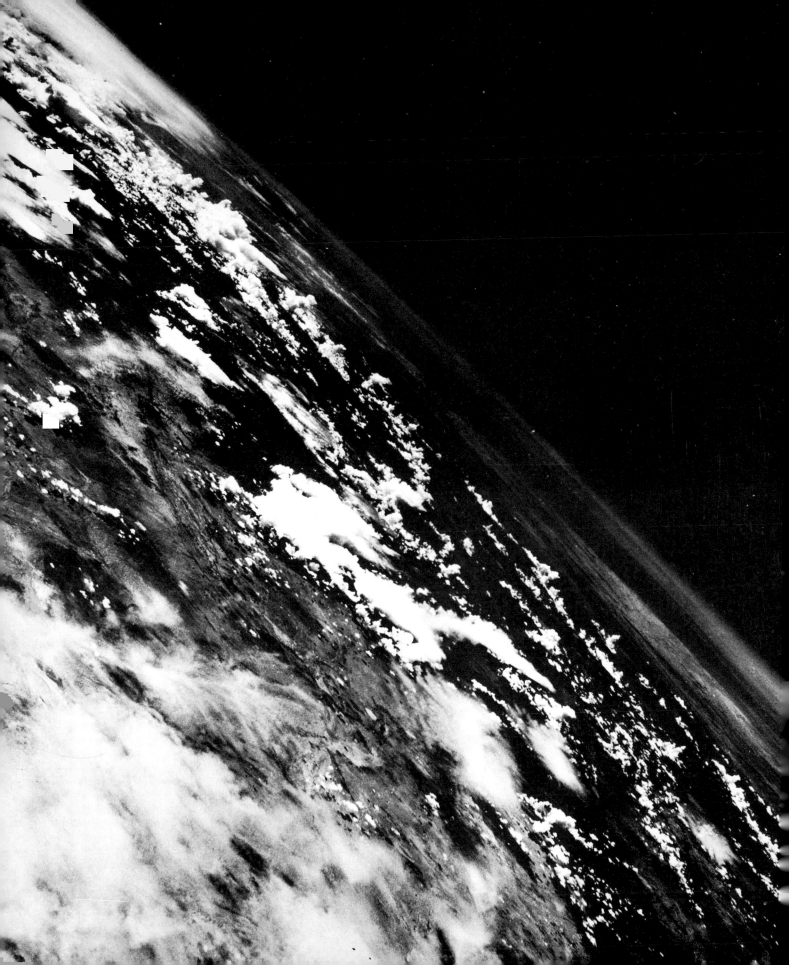

# 13 FROM OUTER SPACE

In 1946 the United States Army launched a number of captured German V-2 bombs, Hitler's secret weapon against England in the last months of World War II, from the White Sands Proving Ground in New Mexico. Instead of explosives, the rockets contained instruments to probe the secrets of outer space. One of these rockets carried a standard De Vry 35mm motion picture camera, which made a continuous record of the ascent through the earth's atmosphere to the threshold of outer space. At an altitude of 65 miles the V-2 began its descent. At 25,000 feet the camera, contained in a sturdy duraluminum box, was ejected. It was recovered with the film intact.

With this experiment, conducted by the Applied Physics Laboratory of The Johns Hopkins University, a new era in photography opened.

As rockets became bigger and more powerful, greater altitudes were reached. In 1959 an Atlas missile carried a camera 700 miles above the earth. The photographs recovered from these flights were remarkable, for they showed the rotundity as well as the curvature of the earth: as conventional aerial photographs resemble maps, these resemble sections of a globe. Their usefulness, however, was limited. Each missile, on reaching the peak of its trajectory, immediately started to descend and consequently only a few pictures could be taken from the maximum altitude. Furthermore, the terrain recorded by the rocketborne cameras was limited to the area visible from space directly above the rocket range. A camera platform, traveling at a constant speed around the earth was needed, from which many photographs could be taken of any desired area.

Even before orbital flight became a reality, it was realized that one of the most useful functions of an artificial satellite would be to serve as an observation post, from which photographs could be taken.

*Sputnik*, the first earth satellite, was not equipped with optical equipment, but in 1959 a camera was put in orbit

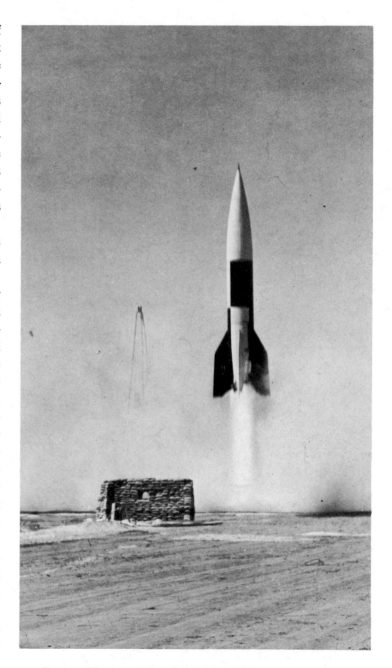

Captured German V-2 rocket leaving White Sands Proving Ground, New Mexico, 1946.

First photograph of the earth from 65 miles, 1946. The camera was spaceborne by a V-2 rocket launched from New Mexico. Applied Physics Laboratory, The Johns Hopkins University.

113

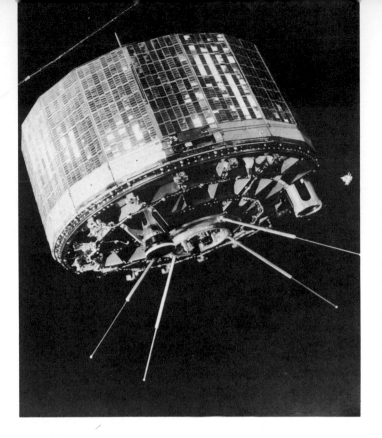

*Tiros VI,* U.S. weather satellite, launched by NASA September 18, 1962.

High gain antenna for receiving pictures from orbiting *Tiros* satellites at Wallops Island, Virginia.

in the 142-pound *Explorer VI*, America's "paddle wheel" satellite, so-called because of its outboard solar cells. *The New York Times* reported, on September 29, 1959, that the spacecraft "has taken the first television pictures of the earth from space. While the first television pictures were admittedly crude, the civilian space agency [the newly established National Aeronautics and Space Administration] said the success of the experiments had demonstrated the feasability of using television for interplanetary exploration by unmanned rockets. One picture released, made on August 14 as it crossed over Mexico at an altitude of 19,500 miles . . . was sufficiently detailed, in the view of space agency scientists, to discern cloud formations."

Meteorologists at once found these hyperaltitude pictures most useful, for at one glance they could see upwards of 10 million square miles of cloud cover, revealing the patterns of storms across entire continents. They saw weather in the making; they could predict the paths of hurricanes and give warning in advance of their approach with an accuracy hitherto unknown.

In 1960 the first satellite specifically designed for weather reconnaissance was launched. It was named *Tiros* (Television and Infra Red Observation Satellite), and carried equipment to measure the temperature of the earth and two modified television cameras to record cloud cover. The images of the cameras were converted to electric impulses which were stored on magnetic tape for transmission to the earth when the satellite was within radio range of a receiving station. There the signals were converted back to images that were recorded on film. *Tiros* circled the earth at a minimum distance of 428.7 miles (perigee) and a maximum of 465.9 miles (apogee) every 99.1 minutes; in two weeks it transmitted 22,952 pictures. They showed the coastlines of the earth with remarkable clarity, but the definition was not sufficient for them to be used for terrain reconnaissance. The ground resolution, i.e. the size of the

Eastern seaboard of the United States,
from Cape Cod to Chesapeake Bay, recorded by
*Tiros VII*, 1963.

smallest features that could be distinguished, was about 3 miles. But the pictures gave the first view of global cloud cover and proved of such immense value to meteorologists that others were hurled into orbit. *Tiros VIII* (1963) extended the services to mankind even further, by providing automatic picture transmission. A local weather station with relatively inexpensive radio equipment can command *Tiros*, when it is within range, to transmit pictures of cloud cover.

In 1965 the Environmental Services Administration (ESSA) of the Department of Commerce accepted the *Tiros* system for day to day operational uses. The *Nimbus* satellites, first launched in 1964, give a complete global coverage every 24 hours; they are earth oriented, and sweep the world in sections from pole to pole.

*Tiros, Essa* and *Nimbus* have greatly advanced meteorology. President Lyndon B. Johnson, in a speech on the contributions of space technology for the betterment of mankind, praised the weather satellite program. "Hundreds of lives, millions of dollars were saved in my state alone," he said, when *Tiros III* gave warning sufficiently in advance of the impact of Hurricane Carla upon Texas to allow 350,000 people to flee to safety — the largest mass evacuation in the history of the United States. Beyond information about storms, weather satellites enable oceanographers to plot sea and river ice, and thus to warn vessels in northern waters of the positions of icebergs and the navigability of rivers and harbors.

In addition to these peaceful uses, space photography of the earth has proved to be of the greatest value to the Department of Defense. It is estimated that more than half of the satellites launched by the United States have military assignments. These flights are classified, and their functions cannot be revealed. Their importance can be judged by President Johnson's statement: "If we got nothing else from the space program but the photographic satellite, it is worth ten times the money we've spent. Without the satellites, I'd

Italy, Yugoslavia, Albania, Greece, from
*Nimbus A* satellite, 1964. Received in
France by the Automatic Picture Transmission station of the French meteorological
service.

115

be operating by guess and by God. But I know exactly how many missiles the enemy has."

The ability to transmit images across hundreds, thousands, even millions of miles has brought us also new knowledge of the planets. Thousands of photographs have been taken of the Moon, for the purpose of determining possible landing sites. *Mariner IV* transmitted 22 photographs of Mars in 1965 from 167 million miles: a distance which took the space craft more than seven months to reach, traveling at 7 miles per second. The photographs were taken at distances of 7,000 to 10,000 miles, and showed thirty times more detail than can be seen through the most powerful telescopes. Features two miles in width could be recognized, and many more craters were discovered on the surface than scientists expected. No signs of life were found, but the evidence was not considered conclusive; it was pointed out that even photographs transmitted by *Nimbus* at 430 miles provide no evidence of man's activities on Earth: a hypothetical Martian scientist could not determine from them the presence of life on this planet.

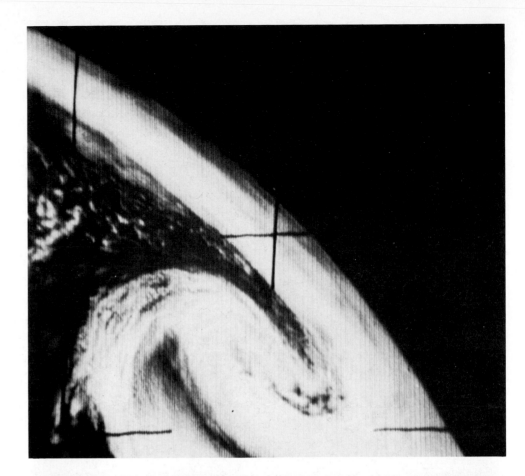

*Left:*
Storm vortex south of Australia.
*Tiros VII*, 1963.

*Right:*
Vortex near Nova Scotia. *Tiros VI*, 1963.

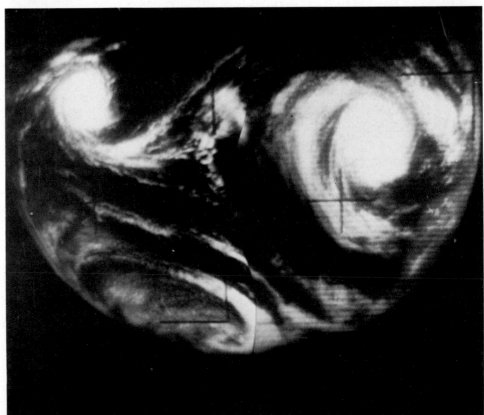

Three Indian Ocean vortices. Mosaic of
three photographs received from *Tiros IX*,
1965. NASA photos.

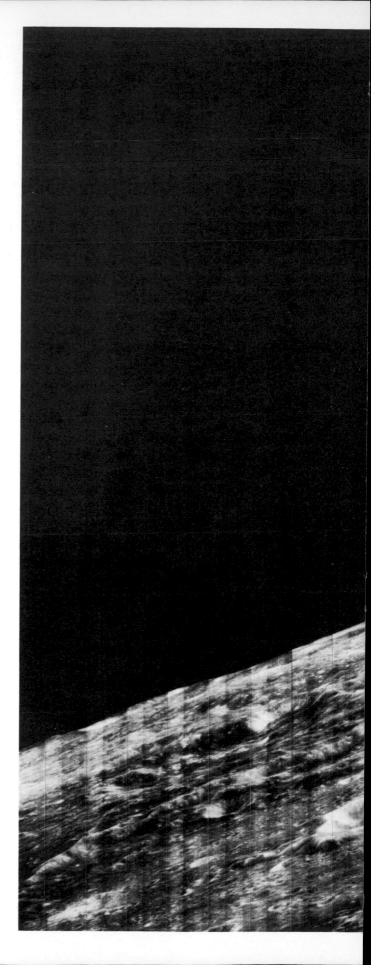

The Earth and the Moon, photographed by
*Lunar Orbiter I,* 1966, on its sixteenth
orbit around the Moon. NASA photo.

Although it is not our purpose to chronicle in this volume the extraordinary achievements already attained in photographing Earth's sister planets, we cannot overlook an important byproduct of this program: the first view of our planet in its entirety, as observed from the vicinity of the Moon: a globe suspended in space. This historic photograph was taken by *Lunar Orbiter I* in 1966, across the craggy surface of the Moon. The quality of the picture is exceptionally fine, because instead of a television system, the images of *Lunar Orbiter's* two cameras were first recorded on 70 mm photographic film, which was processed on board the spacecraft. Each negative was then scanned by a minute spot of light which traveled 18,000 scan lines across bands of the film only a tenth of an inch wide, called "framelets." Variations in the brilliance of the light, as it traveled across the negative were instantaneously converted to electric impulses, which were radioed to earth, where they were converted to light and recorded as photographs on 35mm film, line by line, framelet by framelet. The framelets of film were then placed in register side by side, to produce a composite picture of the entire frame.

This first "long shot" of our planet was a sensation. For the first time we no longer looked *down* upon the Earth, but *at* the Earth — and we realized that every astronomical photograph taken through a terrestrially-based telescope is indeed a space photograph — from spacecraft Earth.

We have since received many photographs of planet Earth from satellites. In 1966 NASA's Applications Technology Satellite (*ATS*) relayed from 22,300 miles images at various hours, showing the "phases of the earth," as it were, in the configuration of the twilight zone or terminator, revealing the waxing Earth, the full Earth, and the waning Earth. The first color pictures of the full Earth were taken on July 25, 1967, from satellite *DODGE* (Department of Defense Gravitational Experiment), built for the U.S. Navy by the Applied Physics Laboratory of The Johns Hopkins

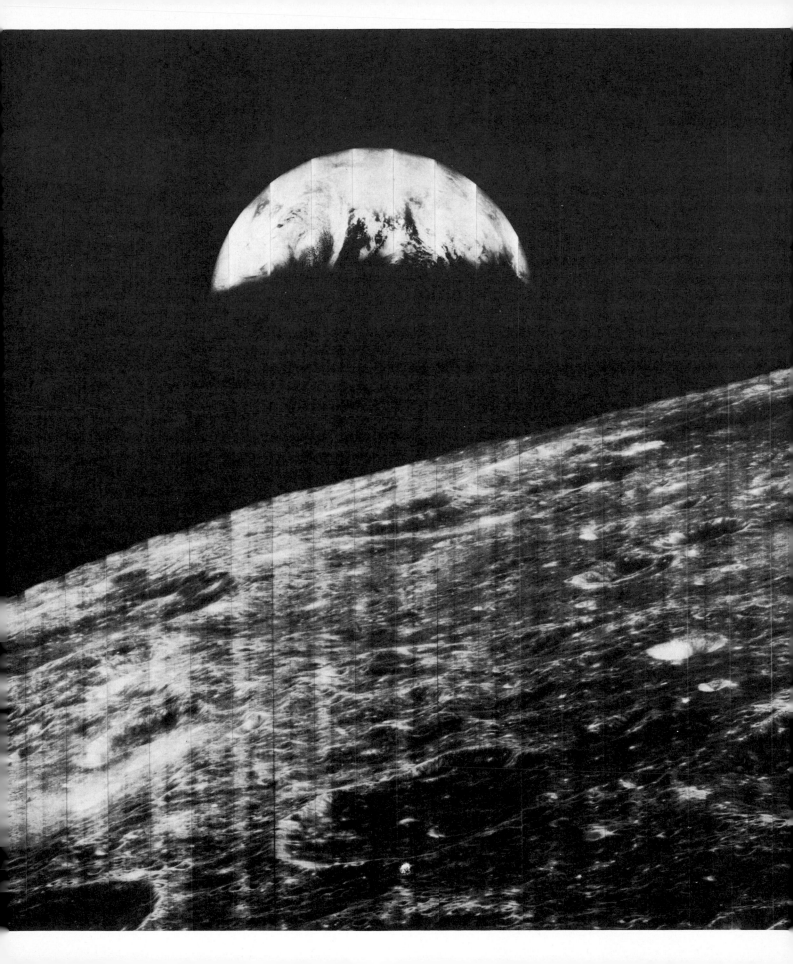

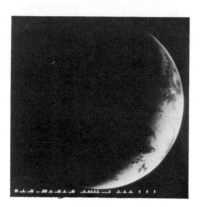

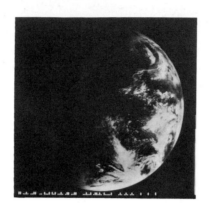

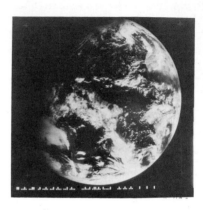

7:23:23 a.m.        9:52:33 a.m.        12:14:14 p.m.

The Earth, November 19, 1967. Six of a series of color photographs from images televised by NASA satellite ATS-III. The satellite was in synchronous orbit at the Equator, positioned at approximately 49° West longtitude, and at a height of approximately 22,300 miles. Dr. Verner R. Suomi of the University of Wisconsin, was in charge of this Multicolor Spin Scan Cloud Camera Experiment. The line of vertical bars at the bottom of each picture is a binary digital display of signals sent to Earth by the satellite explaining details of the picture transmission. The tall bars represent logical 1 and the short bars represent logical 0 in the binary digital system. Each display contains the following information: day, hour, minute and second; voltage of signals; ground video gain of signals; scan mode; sweeps per line; and spacecraft gain.

University: vidicon images taken through red, green, and blue filters were received in Maryland and reconstituted to form color photographs. *ATS-III*, in similar fashion, has produced a remarkable series of 34 color photographs, taken at intervals of approximately 30 minutes from 7:08 A.M. to 11:30 P.M. Greenwich Meridian Time.

But amazing as they are, transmitted images cannot compare in quality with original photographs, brought back intact to earth from orbiting satellites. The first extensive photographic coverage of the earth from space was recovered from the unmanned spacecraft *MA-4* when it was brought to a splashdown in the Atlantic east of Bermuda in 1961. A Maurer 220G time lapse camera took pictures every six seconds from liftoff until the 100-foot roll of 70mm film ran out over the Indian Ocean. Most of the 333 frames were taken when the earth was obscured by darkness or cloud cover. But twenty pictures, taken in two minutes while the spacecraft passed over Africa at altitudes of 101.6 to 101.8 statute miles, showed in a most striking way the potentials of direct space photography. They were interpreted for the National Aeronautics and Space Administration by A. Morrison and M. C. Chown of McGill University; their *Contractor Report* is an exhaustive analysis of the information contained in the photographs, which cover a 2,500-mile strip from Agadir on the Atlantic coast of

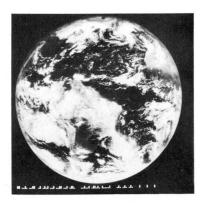

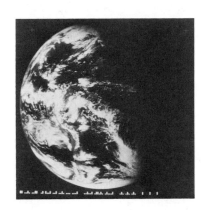

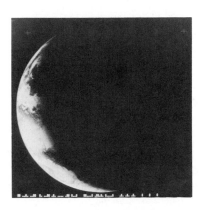

3:13:16 p.m.                                        7:12:01 p.m.                                        11:20:39 p.m.

Morocco southeast over the republics of Algeria, Niger and part of Chad. Most of the terrain is the Sahara desert, and has been mapped, so the interpreters were able to check their findings. The spaceviews are oblique; consequently the scale varies from the foreground to the horizon, about 900 miles distant. The interpreters estimate that had the camera been oriented vertically, the scale of the photographs would be approximately 1:2,200,000. They found that the ground resolution varied from ⅛ to ¼ of a mile, "depending on the contrast, shape and orientation of the features considered, and the nadir angle of the photo."

Their most striking observation is that hyperaltitude space photographs, because of their small scale, reveal features invisible in conventional airviews. "The MA-4 photographs," they write, "are notable as the first series of photographs on film recovered from space which covered a land area of continental extent. Unlike previous aerial and *Tiros* photographs, they give a view of the enormous expanse which is both all-embracing and comparatively detailed. They display at a glance patterns so extensive that they can otherwise be revealed only by decades of hazardous ground travel or months of work with air photographs." They were able to identify geological formations and to locate land faults hundreds of kilometers in length indicated only roughly on existing maps.

A second advantage of hyperaltitude space photographs is that each one shows vast terrains in correct perspective, from one viewpoint and at one moment of time. Thus they are far more accurate than mosaics of the same area pieced together from photographs taken from the constantly shifting points of view of conventional aircraft at random periods of time, extending from dawn to sunset or even over weeks and months, depending upon clear weather.

On the first U.S. manned orbital flight, *Mercury VI*, launched February 20, 1962, Lt. Col. John Glenn carried a modified 35mm camera. Photography was of secondary importance in this flight, but Glenn was able to secure a few pictures and to demonstrate the advantage of the hand-held camera over an automatic one mounted in the space craft, for with it pictures can be taken in any direction and at any time a view of the earth presents itself. Film is not wasted when the earth is obscured by impenetrable haze or cloud cover.

On subsequent manned flights somewhat larger cameras have been adopted: the Hasselblad 500C, the Hasselblad SWC, and the Maurer 220G. These accept 70mm roll film; each picture measures 55 x 55mm (approximately 2¼ x 2¼ ins.). The Hasselblad 500C was used with an 80mm lens or, occasionally, with a 250mm lens. Because focusing and parallax presented no problems to the astronauts from

their great distances from Earth, the reflex mirror and ground glass focusing screen was removed from the Hasselblad 500C, which became, in effect, a simple box camera. The Hasselblad SWC is specifically designed for taking extremely wide angle photographs: it has a 38mm lens, covering 90° angle of view. The Maurer 220G is a time lapse camera, which operates automatically until the film runs out. It was fitted with an 80mm lens. Color film was specially coated on thin base to permit a maximum number of exposures for each magazine. Ektachrome film was supplied by the Eastman Kodak Company in several emulsions, and Anscochrome 200 film by General Analine & Film Corp.

During the *Gemini X* flight, Lieutenant-Colonel L. G. Cooper took a Hasselblad SWC on his space walk. It was attached to his space suit. Somehow the strap broke, the camera floated beyond his grasp and became a satellite.

Pictures taken by the astronauts have shown increasing improvement in ground resolution with each flight. Cities, railroads, pipelines, airfields can clearly be distinguished upon them. The amount of information about the natural resources of a continent that can be extracted from space photographs is astounding. Professor Robert H. Colwell of the University of California at Berkeley made an exhaustive interpretation of a *single* photograph of Australia taken from the *Gemini V* spacecraft on August 27, 1965, at an altitude of 165 miles. He then checked his findings on the spot with an Australian scientist. They flew over much of the area in a low-flying light plane and made oblique photographs of terrain features. "The check," he wrote in *Scientific American,* January, 1968, "showed that the interpretations previously made from the Gemini photograph were correct in all respects." He noted: "According to Australian scientists, virtually all the significant geologic, soil and vegetational features found in approximately 70 percent of the continent's arid regions are represented in the *Gemini* photograph that I have described. It seems evident that one of the best ways to produce suitable reconnaissance maps for the remainder of underdeveloped Australia and for other underdeveloped areas of the world would be through the use of space photography, supplemented . . . with field checks."

On their voyage to the Moon in December, 1968, the *Apollo 8* astronauts, Colonel Frank Borman, Captain James A. Lovell Jr. and Major William A. Anders, photographed in color the receding Earth. They watched our planet grow smaller and smaller. Then it disappeared as they circled the hidden side of the Moon. Suddenly they saw the Earth again. "Nothing that happened during the flight was as awe-inspiring as this moment," Colonel Borman said. "Even out at the Moon, the deep blue of the Earth is the only color you can see in the Universe." Their photographs of the Earth from the great distance of 240,000 miles, and of the Moon from as close as 69 miles, are the most detailed that we have yet received from outer space.

The airborne — and now the spaceborne — camera has brought to all mankind a new conception and understanding of the universe. It is the best means we have for measuring the planets, observing the inaccessible, making the invisible visible and immensity perceptible. It makes the miracle of flight tangible: what is seen from a point in space is held forever, for our study and contemplation.

The Earth. Photograph taken by the crew of *Apollo 8* spacecraft on their voyage to the Moon, 1968.

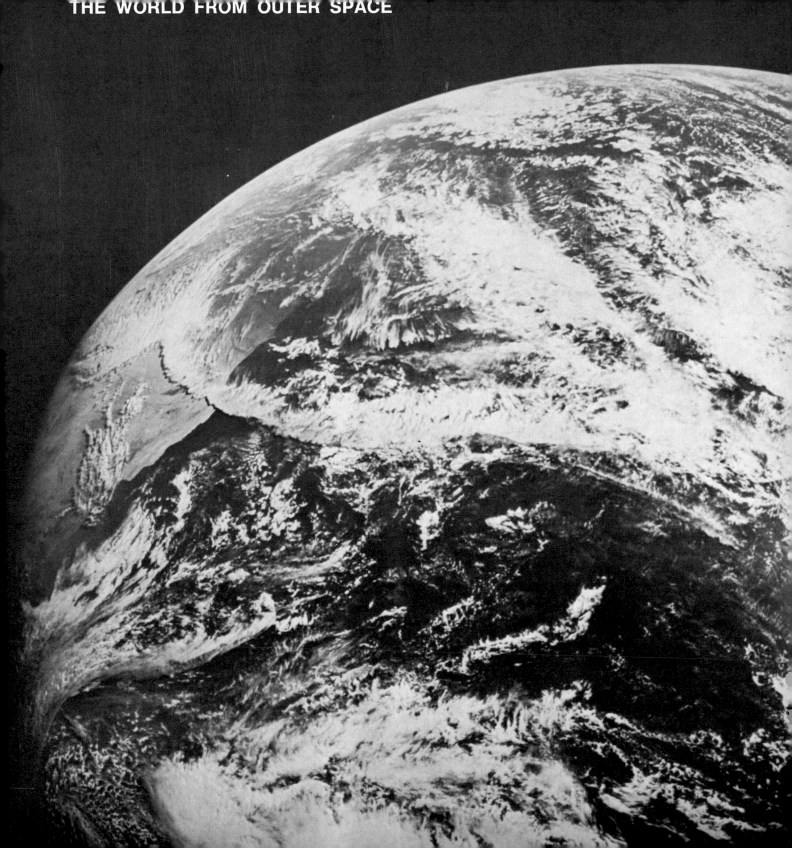

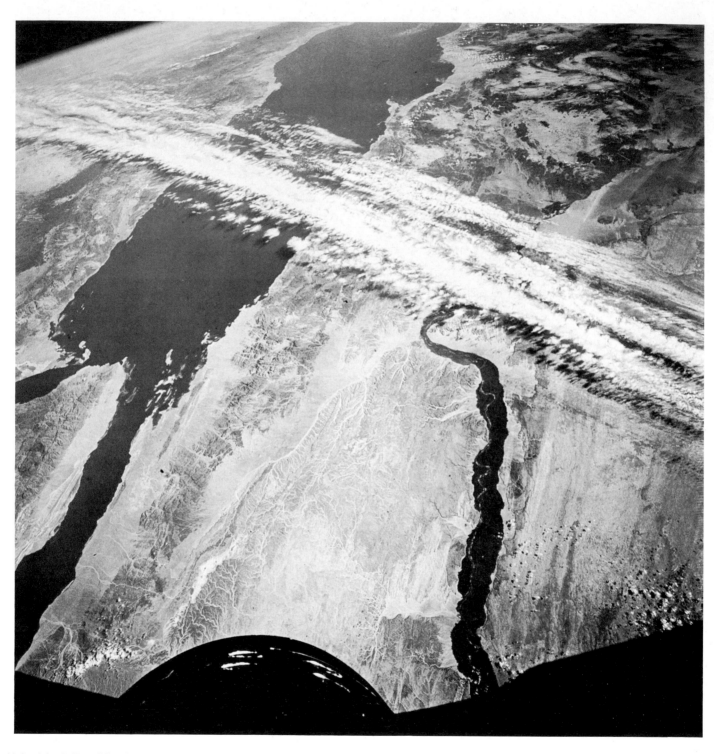

United Arab Republic, Saudi Arabia, Red
Sea, Nile Valley. In foreground appears
part of the spacecraft.
*Gemini XII,* 1966.

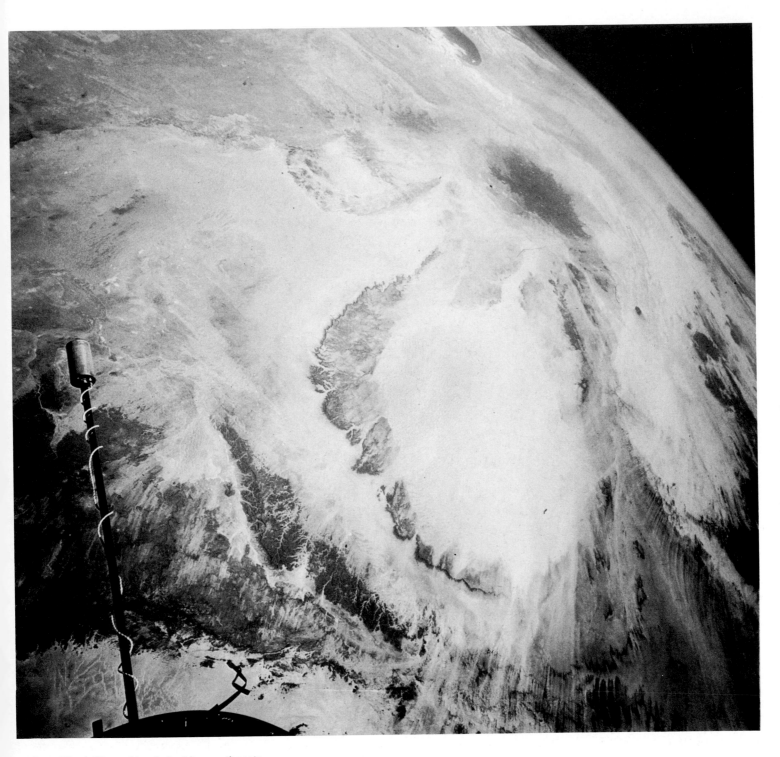

Libya, Chad, Niger, Algeria looking northeast;
Al Haruj, Al Swad, Great Sand Deserts, Mediterranean
Sea and Gulf of Sirte in background.
*Gemini XI*, 1966.

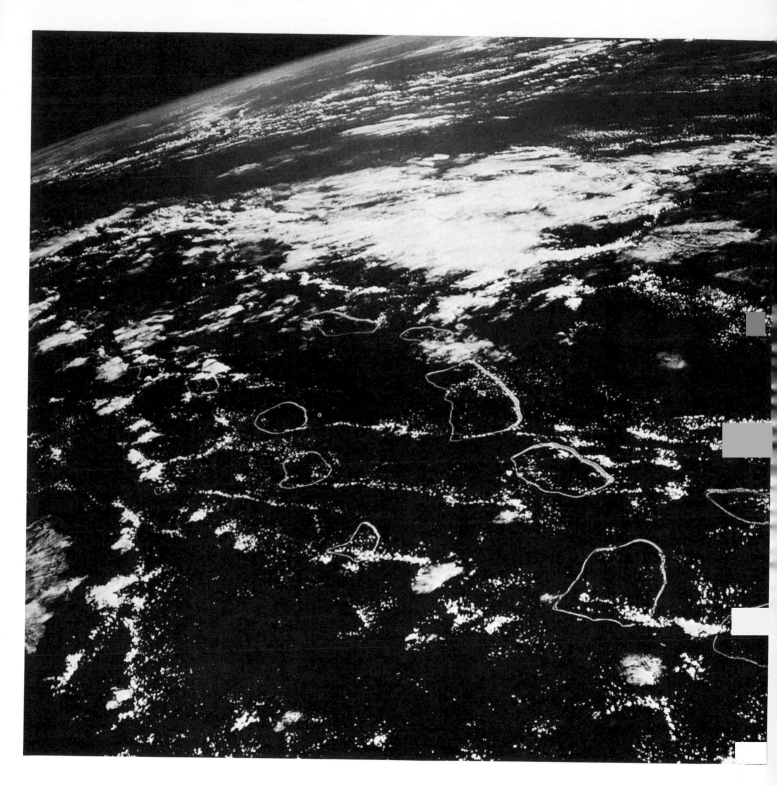

Tuamotu Archipelago in the South Pacific,
looking southeast.
*Apollo 7*, 1968.

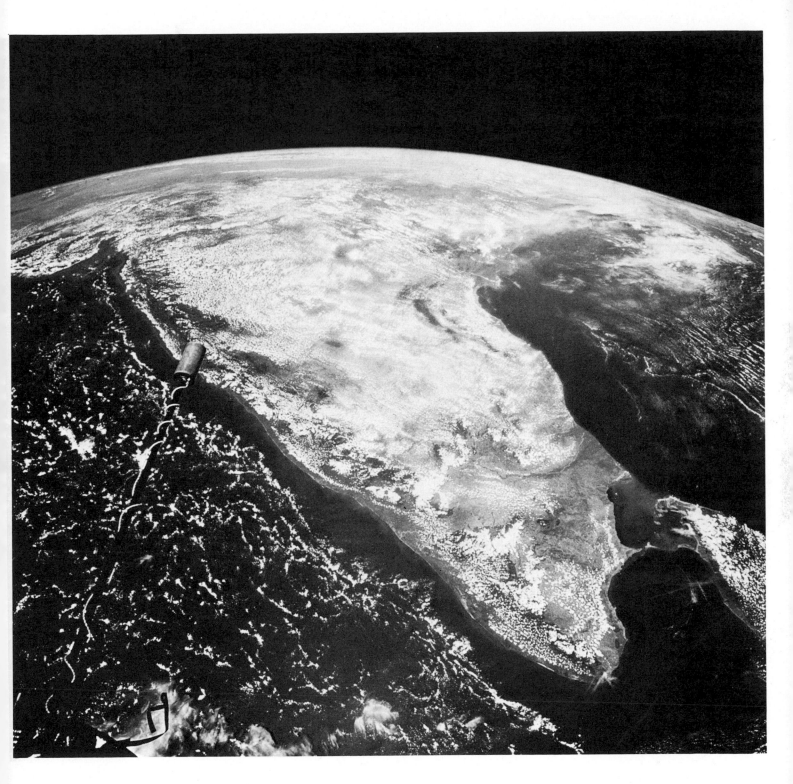

India and Ceylon.
*Gemini XI*, 1966.

City of Kagoshima and Kagoshima Bay area
of the island of Kyushu, Japan.
*Apollo 7*, 1968.

The Agena Target Docking Vehicle
following tether jettison.
*Gemini XI*, 1966.

Gulf of California; mouth of Colorado River;
the Great Sonora Desert.
*Gemini IV,* 1965.

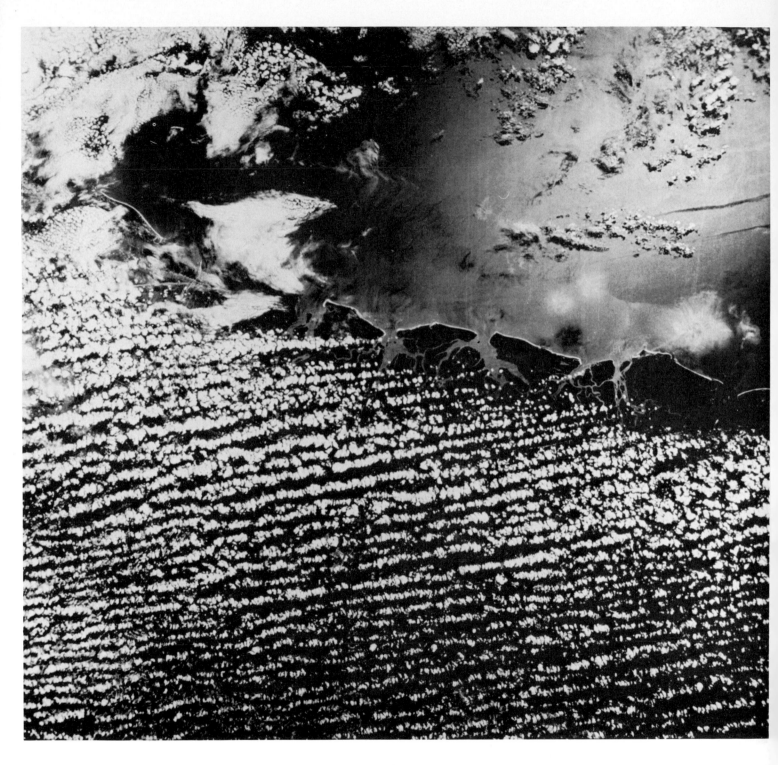

East coast of the United States,
between Savannah and Brunswick, Ga.
*Apollo 6,* 1968.

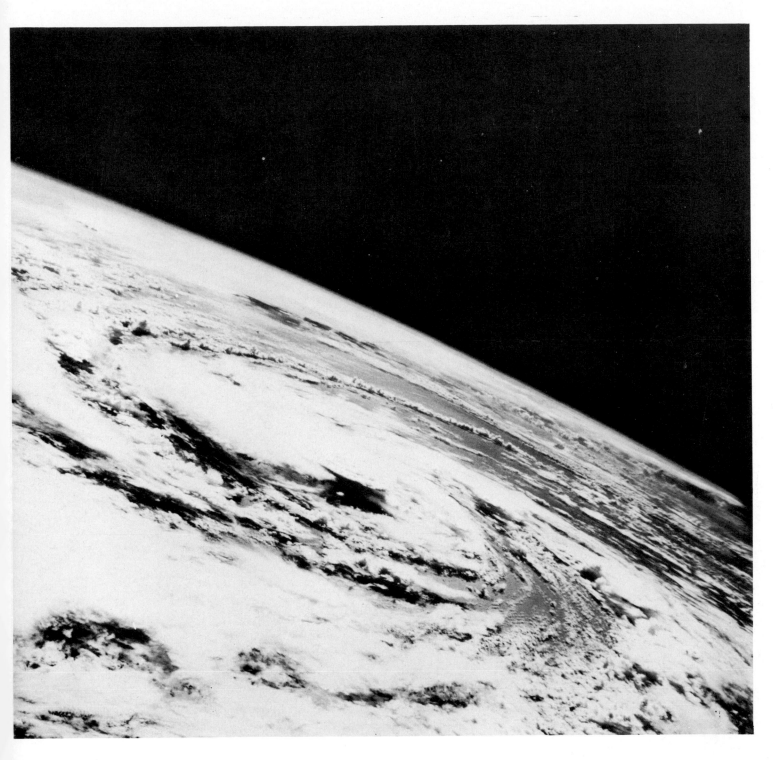

Hurricane Gladys, about 150 miles southwest
of Tampa, Florida. Wind velocity, 80 knots.
*Apollo 7*, 1968.

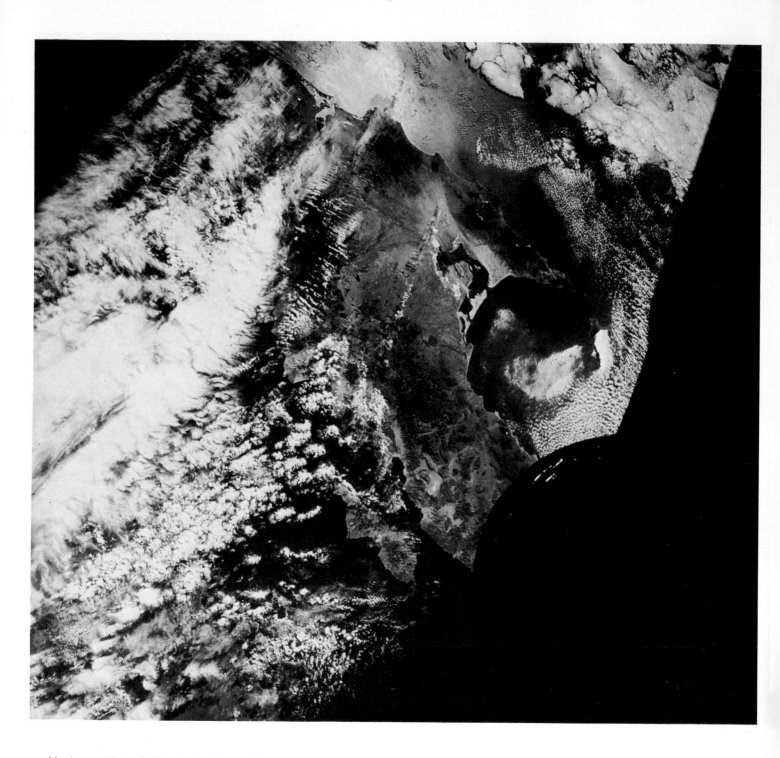

Mexico and Baja California, looking south.
*Gemini XII,* 1966.

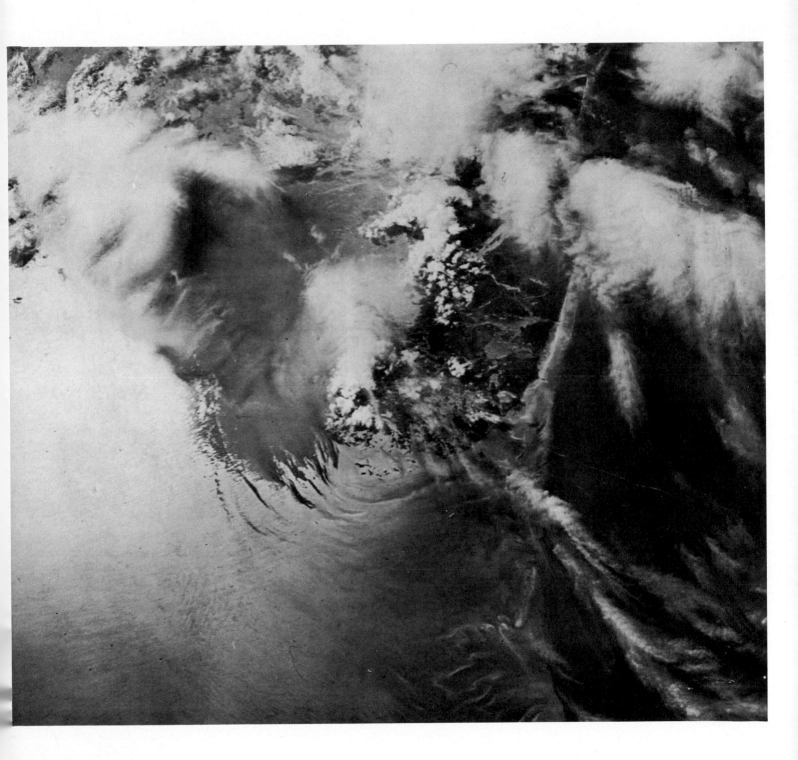

Andros Island in the Bahamas. The Tongue
of the Ocean, where depths exceed 900
fathoms, is on the right: Grand Bahama
Bank is on the left.
*Gemini IV.*

The Earth from 240,000 statute miles. The
sunset terminator bisects Africa. The
width of the unnamed surface of the Moon
at the horizon is about 175 kilometers.
Photographed in 1968 by the crew of
*Apollo 8*.